THE
UNDERWATER
MUSEUM

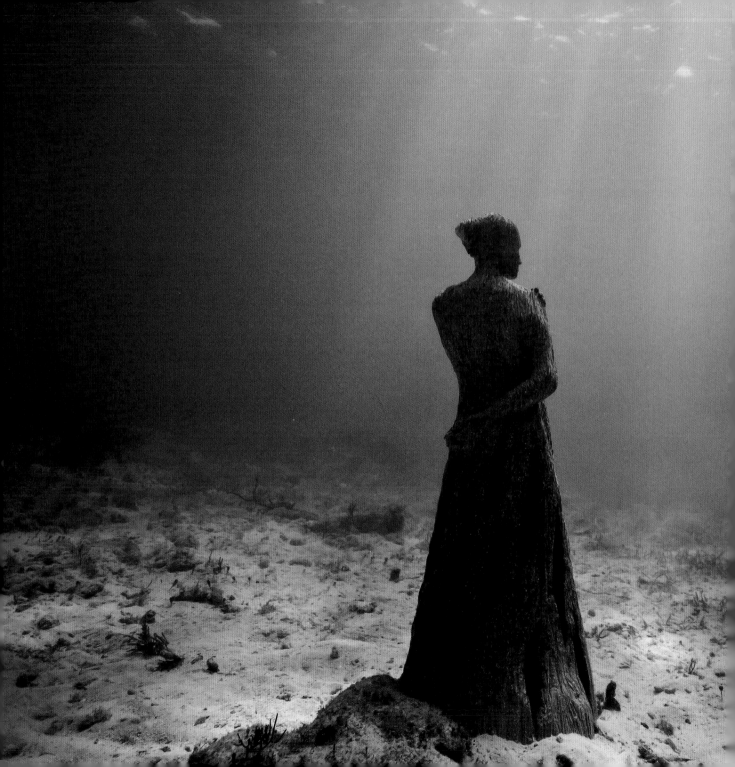

THE UNDERWATER MUSEUM

THE SUBMERGED

SCULPTURES OF

JASON DECAIRES TAYLOR

Essays by Carlo McCormick

and Helen Scales

CHRONICLE BOOKS

SAN FRANCISCO

Library of Congress Cataloging-in-Publication Data
available.
ISBN: 978-1-4521-1887-1

Manufactured in China.

The author is grateful for the sponsorship of SIGMA in
supplying photographic lenses.

Design by Pamela Geismar
Typeset in Gotham and PMN Caecilia

10 9 8 7 6 5 4 3 2

Chronicle Books LLC
680 Second Street
San Francisco, CA 94107

www.chroniclebooks.com

CONTENTS

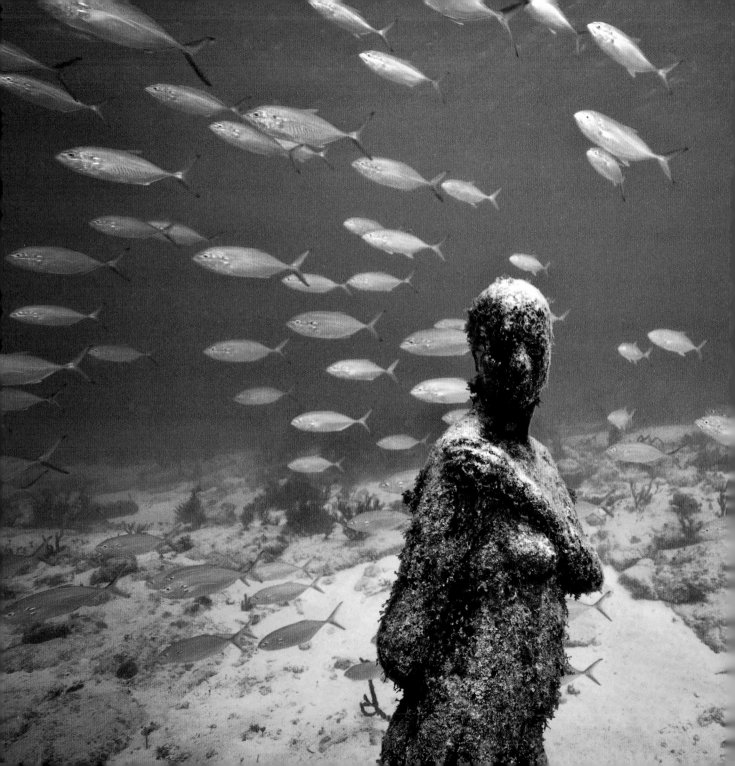

FOREWORD

by Jason deCaires Taylor

Being underwater is a deeply personal, liberating, and otherworldly experience. Like many interactions with the natural world, submersion is both humbling and life affirming. In my work I aim to encourage insight into our human relationship with the unchartered space that occupies over two-thirds of our planet.

I have always been an explorer. When I was a child I lived in Malaysia with my parents and sister. We would often take to the seas on the weekends to explore the incredible reefs and islands that surrounded the east and west coasts of the peninsula. By the time I had reached secondary school, we headed back to the UK, where I substituted disused chalk pits, old paper factories, and a derelict empty railway line for coral reefs. I suppose like many teenagers I enjoyed the notion that I might find some secret place or fantasy world. In hindsight, I see that, besides the solitude and adventure I discovered in these places, I was always fascinated by how nature had reclaimed human environments. Weather and plant life were slowly eroding away our marks and encroaching on the structures. Later in my adolescence, I became a graffiti artist—spray-painting walls, tagging, and looking at public spaces as places to communicate through art. This in turn led me to art college, and I centered four years of study on art and the environment.

After finishing my sculpture degree I made a tentative plan to make a living with other work and make art in my spare time. As many art students have found before me, the tension between creative expression

and making a living presents its own difficulties. I embarked on several different careers—a brief stint as a paparazzo (one of the lower moments), several years as a diving instructor in Australia, followed by several more working in set design and construction for concerts and arenas. Twelve years rapidly slipped away and my original plan to create artworks had started to derail. So I decided to buy a small diving center in the Caribbean to support myself and, at the same time, have the opportunity to focus on my art and explore my connection to the sea. The intersection of art and the ocean struck me as being excitingly unexplored terrain. I quickly realized that my passion was not for teaching scuba diving but for creating art that would facilitate marine life.

I don't believe in fate, but strangely enough I found that my diverse background —my wanderings that up to that moment had felt completely directionless and unintentional—had in fact provided me with precisely the skills I needed to realize the underwater projects.

My graffiti background, though a far cry from the media I am working in now, still feels relevant to my work today. Street art gave me the ability to think of art as a temporal encounter. My objects are moments in passing. As the graffiti is washed off the trains, so too are my sculptures covered by algae. Details and forms are lost forever, to be remembered only in photographic prints. But now the roles of defacing surfaces have been reversed. Instead of leaving my mark on the environment with my work, the environment is leaving its mark on my work. Since my days as a teenage tagger I've known the value of good photography to record fleeting moments of art. And, strangely enough, my time as a paparazzo photographer gave me the skills I needed to create a visual diary of my work. Art college gave me the technical skills to make molds and armatures, understand materials, and look at space differently. Naturally my years as a diving instructor helped me work out the physics of water, and gave me an understanding of how coral and marine life function. My theater and set design work taught me about load bearings, cranes, transportation logistics, and, perhaps most important, it gave me the ability to think on a large scale—essential if you're going to realize anything in the vast context of the sea.

It was all coming together. Somehow my eclectic path in life was now culminating in something real and tangible. For the first time I felt that I was making work that offered a new perspective on the world. It had also become of the utmost importance to me that what I was doing would benefit the natural world and not needlessly occupy space on an already cluttered planet. From that day to this I have successfully installed over five hundred underwater sculptures and created more than one thousand square

meters of habitat space for various types of marine life.

Of course, as you would expect, a huge collaborative effort is needed to complete these installations and I have come to owe many people thanks along the way. First, on the small island of Grenada in the West Indies, where it all started—the Grenada Ministry of Tourism and the Ministry of Agriculture, Forestry and Fisheries, whose faith in my proposal was the vital seed; and Jerry Mitchell and Phil Saye from Dive Grenada, who were both pivotal. Thanks to all the amazingly agreeable life models (too many to mention) who have patiently stood in their underwear covered in Vaseline while I applied plaster and fabric to their bodies, quite often removing the odd body hair (or dozen) in the process. I'm indebted to Todd Barber from Reef Ball whose invaluable artificial reef experience has guided me on many occasions; and Jaime Gonzalez Cano, director of the National Marine Park in Mexico, and Roberto Diaz of the Cancún Nautical Association, whose collaboration and vision laid down the foundations of MUSA (Museo Subacuático de Arte). On the engineering front, a heartfelt thanks to Mario Chacon from Marenter, his family, and all the crew on BD1; much appreciation to Mario Narravo and Christian Sandino Taylor for their instrumental experience in film and video editing; and a special thanks to the artist assistants: Rodrigo, Jorge, Lucio, James, Jess, and the ever hardworking Karen, who have all toiled through often very tough tropical conditions.

Of course, I must also thank the lovely Donna, my silent partner in this endeavor, who has shared my dream from the beginning and whose unconditional love has allowed her to tolerate some of my worst eccentricities, from keeping a frozen dog in the fridge (for casting) and packing numerous white bags of powder in her hand luggage (plaster) to spending weeks underwater and then endlessly moaning about jellyfish stings. She has seen it all. My love for her is as infinite as the ocean that surrounds my work.

Lastly my parents, Roy and Christine, who throughout my life gave me the crucial confidence and freedom to explore, whether it be the ocean, a disused building, a continent, or a book on a shelf. They always gave me uncompromising love and unwavering support, and for this I will be eternally grateful.

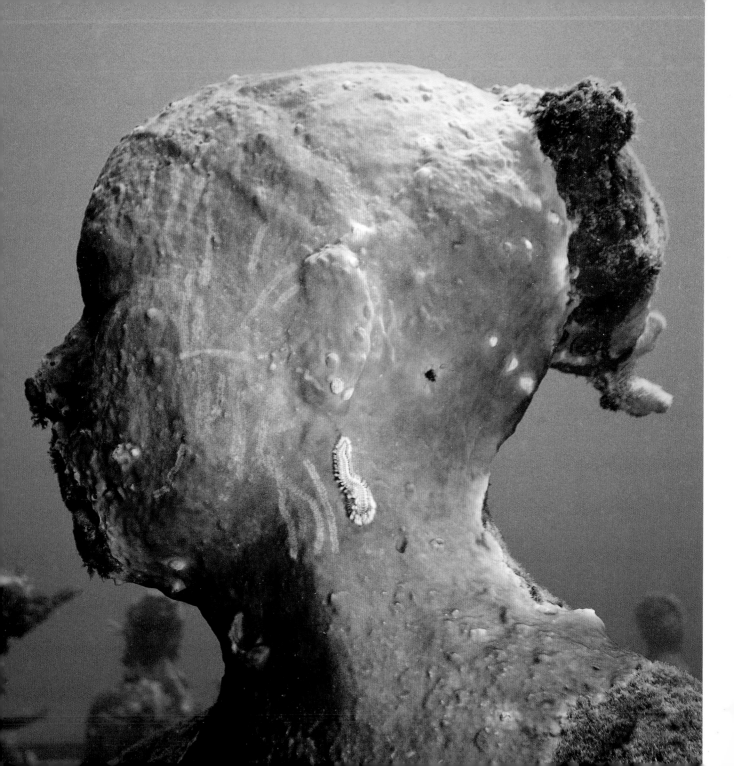

DEEP SEEING

MEANING AND MAGIC IN

JASON DECAIRES TAYLOR'S

OTHERWORLD

by Carlo McCormick

At some fundamental level, art works in areas beyond our understanding and articulation. Through means of representation, and even abstraction, it shows us something we do not otherwise see, puts to visual what eludes explanation in other terms. This is not merely a reason for the surreal or spiritual in art, it is just as much why we continue to paint landscapes or human figures, because something like beauty is so very hard to describe. As such, much of the best art resides in mystery, mapping zones of experience that no matter how frequently we return to them seem nearly uncharted.

Our virtue and delusion among all species resides in how we use imagination as a tool to fill in the voids of comprehension, to picture what might be there or conjecture the reasons for what is. Call it our horror vacuii—the pathological fear of the empty that insists we fill it up—or perhaps it is our equally innate compulsion to make our mark wherever we go, but in the mind or the material world, we can only comprehend what is not of us by somehow making it our own. Much as early man looked to the vast unknown of the heavens above and projected a diagrammatic cosmology of animals and gods upon the stars, using the known and recognizable to make intelligible aspects of the universe beyond our ken, Jason deCaires Taylor proffers the identifiable as a kind of literal anchor by which we can navigate the mysteries of the ocean deep with some level of discernment.

This process of filling in the gaps, of mapping the unknown, and of seeking

(even needing) an explanation is so essential to the human condition that it must be hardwired into our psyche, as integral to our consciousness as it is to our propensity for creativity. This is not to say that deCaires Taylor is wholly as clueless as those of yore who made up implausible pictures in the sky and left us astrology, religion, and so many other superstitions that continue to dominate our lives and serve as a testament to how truly desperate our collective desire for some explanation remains. In fact, Jason's art emerges out of a great deal of primary experience, direct knowledge, and science—so much so that when he tries to explain it to an art critic, well, my eyes just glaze over. Nonetheless, Jason deCaires Taylor is practicing a kind of art making that is as ancient and elemental as conceivable in this twenty-first century of civilization. Unless you are among the more unorthodox of the aforementioned believers, who perhaps believes in the lost city of Atlantis or that our history is built on advances given to us by alien visitors, we would have to agree that in process and content, Jason's art is very much predicated on the present— at once enabled by scuba technologies such as pressurized air tanks, supported by the increasing facility of materials and casting techniques, informed by our evolving understanding of marine biology, and driven by the urgency of new ecological imperatives in which human behavior from industry to tourism and trade is threatening already precarious ecosystems.

What connects deCaires Taylor's work to the most ancient lineage of art and artifact is neither the craft nor the knowledge behind it but rather how it is beyond all that is still predicated on faith. The worlds he invents and the narrative possibilities he conjures involve a kind of magical thinking, not simply in their fantastical aspects, but more specifically in the anthropological context of belief systems whereby dreams invoke realities, and as corollary changes in thought impact the real world. For all its otherworldliness, the underwater museum is obviously more a behavioral intervention in our reality than a mystical one—its premise that these sculptures can be home to marine life is based on science rather than prayer, and the real need it addresses of trying to create new tourist ventures to divert human traffic away from frailer, endangered spaces is closer to the logic of urban planning than the "build it and they will come" optimism that has engendered so much of our architectural folly.

Perhaps it's not the kind of wishful magic that gives us voodoo or shamans or any number of clichéd superstitious habits (from avoiding black cats and broken mirrors to believing in wishing wells and good luck charms), but there is an unmistakable aura of the metaphysical at play in deCaires Taylor's aquatic installations. We trust these

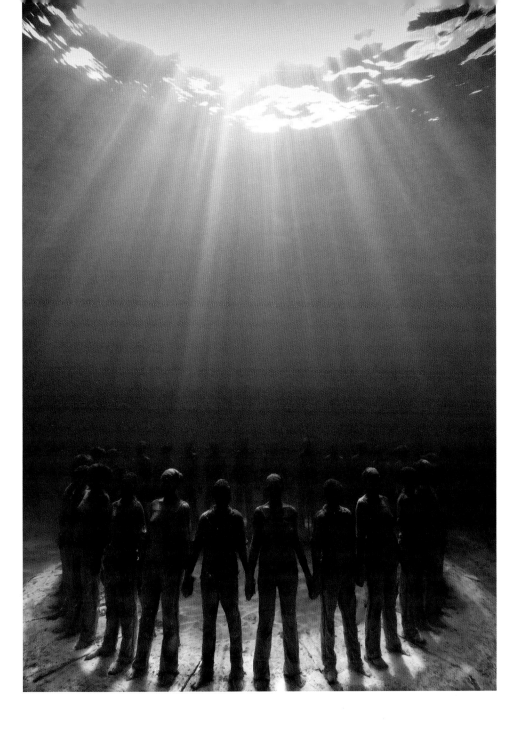

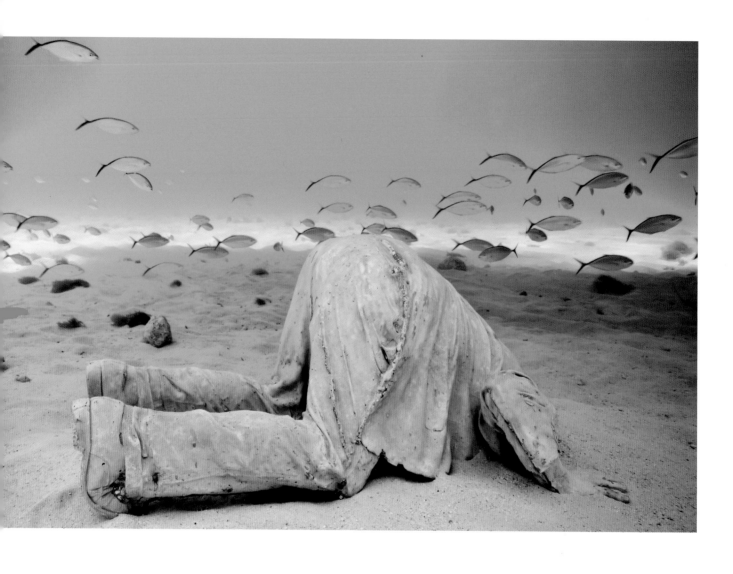

to be more a matter of ideas or representation than divine forces, but ultimately they work in a similar fashion. Highly symbolic, at once metaphorical and allegorical, these issues of transcendence, transpersonal experience, mortality, decay, and any number of questions into the nature of human existence are inevitably posed by his sculptures, particularly so in the context of their environs. How much the average scuba adventurer will want to ponder the profound riddles of life is not for us to speculate, any more than we would presume to know how many of those who visit the pyramids or Parthenon do so to attain spiritual revelation. That's hardly the point in an age where even the humbling spectacles of nature or human endeavor are reduced to photo ops. What is relevant, however, is how the effect of an experience works, regardless of whatever questioning or insight it levies on the soul. When you look at a tribal mask, you don't have to know anything about the peoples or their deities to still feel the juju. Maybe, like many visitors to the world's wonders, you might simply ask how the hell did Jason do that (a good question, but great magicians never reveal their tricks—except when they do), or better yet you might feel compelled to learn more about the coral and fish you encounter, but primarily, and above all else, you will certainly go "Wow."

The "wow" effect is not incidental to deCaires Taylor's work; it is intrinsic. Though it is hardly part of the highbrow lexicon by which we discuss aesthetics, we might as well admit that eye candy can be a laudable quality in fine art, and in many cases, essential to those transformative works that attract people who would otherwise have little regard for art. We might in such a regard suspect that many who have been awed by Michelangelo's Sistine Chapel couldn't give a toss about painting per se, any more than those of us who do not ascribe to the creation myth will still behold it with a degree of reverence. Without a proper survey of the many thousands who have visited Jason's ocean-floor empire, let's just guess that few are typical culture-vulture art lovers, and perhaps not so many more are fanatical divers. All are fundamentally changed, however, by being there, and each in turn is informed about a whole lot of stuff that they not only didn't know but probably hadn't even considered before. In this case the meaning and the mystery are indivisible, the possibility for truth very much predicated on the viewer's capacity to take the leap of faith, all that is conveyed to us a matter of both what the artist and nature itself has to tell us, and our ability to pose the riddle, much like Elihu Vedder's *Questioner of the Sphinx*, inextricably dependent on being there.

A veteran diver who only discovered his true voice as an artist precisely when he found a way to marry his two great passions

of the underwater world and sculpture, Jason deCaires Taylor understands the language of the sea and sculptural form with uncanny acuity. Both are certainly mediums of tremendous power, each capable of stunning poetics, but it is in his mastery of both that a more potent alchemy of communication is achieved here. This is to say that inasmuch as the underwater museum may fill us with wonder, that is not only the intent of this art; it is its most deliberate purpose. Though perhaps evident, it is important to emphasize this because we might easily presume that the overwhelming effect of awe and curiosity that Jason's installations evoke would otherwise be due to the tropical aquatics (it is, after all, not unlike what we might feel diving any coral reef) or the rather unbelievable circumstance of the art's topographical situation—and in this we should acknowledge the conceptual integrity of deCaires Taylor's endeavor as belonging to the legacy of Earthworks artists like Smithson, Heizer, and De Maria. Simply put, we encounter this art with a sense of wonder—because it is inherently filled with wonder, not just the staggering beauty of this place so unlike our own, but the astonishment, admiration, and amazement the artist himself feels.

We began with the perhaps unlikely comparison to that time when people looked to the stars to mark and manifest their mythologies. It is perhaps just as far

a stretch as astrology to describe this act as art, but certainly we can understand it within the inspirational, visionary tradition of unfettered imagination. Liken it to a game of children looking at clouds in the sky to see all sorts of fantasy forms in their shapes. Wonder, after all, is not just the province of art and magic—it is the mindscape of youth. Oddly, however, what is seen in the abstract void is rarely the utterly fantastical as it is the known. Kids may see monsters, but more typically they will point out resemblances to the recognizable, and most of our constellations (archer, ladle, bull, crab, fish, and the like) are pretty mundane in the scheme of things. When you think about it, it is quite an exceptional feat for an artist to gaze upon the waters and imagine putting his art way down below the surface. We could well consider it an even more brilliant bit of thinking for that same artist to pursue such a fantasy with a visual vocabulary so firmly tethered to our own world.

Rather than populating his underwater sculpture garden with the unearthly and phantasmagorical, Jason has clearly opted for the unmistakably quotidian. Clusters of people congregating in silent ritual, individuals frozen in the solitary rapture of their timeless space, a lone home, a guy lounging before the TV, the iconic everyman's Volkswagen car, the domestic still life—deCaires Taylor knows full well that to understand what he wants to say we need

to be able to read it. I suppose he could have gone for an outrageous array of mermaids, lost cities, mighty Poseidons, Nemo's Nautilus, and demons from the deep (what lies below, much as the heavens above, is just the kind of unknown we love to project our fears and fantasies on), but that would have been the kind of kitsch best left to theme parks. Just as the strangest encounter one can have in a truly foreign place is to run into a friend from down the road, deCaires Taylor knows that manifesting the ordinary within the unusual is the key to the extraordinary. And if all our adventures into the unknown are ultimately less about seeing something new than about getting a new perspective on the lives we must inevitably return to, Jason gives us that most special gift here of allowing us to see our own lives—what we do and all the things we give value to—as if from an alien perspective. There are things living down there so phenomenal that they boggle the mind, but here we witness something more, things we know even if we don't always understand their meaning, and it is in the act of self-recognition where a mere narrative becomes something more that we call, for lack of a better word, art.

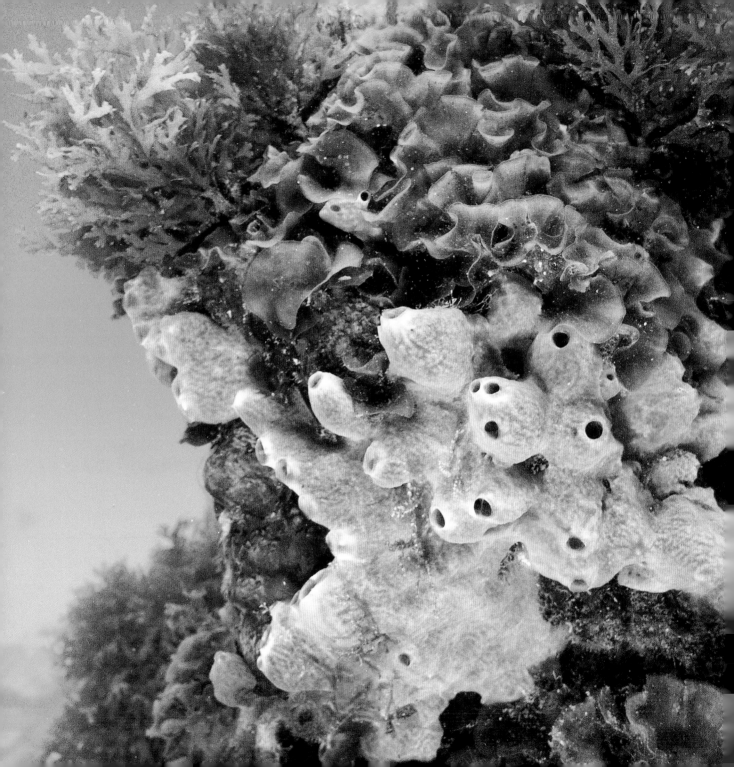

FROM POLYP
THE SCIENCE OF
TO RAMPART
REEF BUILDING AND HOW

ART CAN INSPIRE

A SUSTAINABLE FUTURE

by Helen Scales

There are many ways to contemplate a coral reef. You might peer through an airplane window and see a coastline with a bright turquoise margin trimmed in white surf. You might spot the giant ring of an atoll clinging to the sides of an undersea volcano. Seen from above, it becomes fathomable that coral reefs house riotous forms of life, protect land's edge from battering storms, and feed millions of people.

Get much closer to a coral reef—look at it through a microscope—and you'll see a whole other world reveal itself. Each colony of reef-building coral is itself built from thousands of polyps that look like miniature pulsating flowers, peeping out of perforations in a skeleton sculpted from bone-white calcium carbonate. Inside each polyp are millions of cells, clustered like tiny marbles. These zooxanthellae, nick-named "zoox," give corals their bright colors and make life possible in parts of the ocean where nutrients are in short supply. They harness the sun's energy to create sugars, some of which leak out into the coral polyp. And in return for this free meal, the zoox get a safe, sunny home.

Many people nowadays have the means to see coral reefs for themselves, a snorkel tube in their mouth or blowing noisy bubbles from a scuba tank. From this point of view, captured increasingly in film and photographs, reef ecosystems flaunt their astonishing diversity of living things. When photographer David Liittschwager recently placed a one-cubic-foot metal frame onto a reef near Tahiti and watched it for twenty-four hours, he saw six hundred species

living inside or swimming, crawling, and ambling through the small space. Coral reefs cover less than 1 percent of the oceans but are thought to be home to a quarter or even a third of all marine species. Brimming with so much life, coral reefs put on one of the most colorful and dynamic spectacles of the natural world.

How exactly so much life piles up in such a small portion of the ocean remains a tantalizing puzzle. Studies are beginning to reveal how even more life lies hidden inside a reef. The so-called cryptofauna includes worms and shells that drill into the reef structure and sponges that filter water as it percolates through honeycomb crevices. Scientists around the globe are working hard to discover all the species that live on reefs and to figure out how these complex ecosystems fit together.

REEFS ARE AT RISK

Coral reefs face numerous problems today that play out at the same scales at which we observe them. Looking down from an airplane, you can see the wide seascape across which climate change inflicts a three-pronged attack. The seas have become 30 percent more acidic since the industrial revolution because they absorb a lot of the carbon dioxide human activities emit. Scientists estimate that by 2050 the oceans could be so acidic that only 15 percent of the world's reefs will be able to keep growing;

everywhere else their carbonate skeletons will simply begin to dissolve away. With rising temperatures come rising sea levels as waters thermally expand and ice sheets and glaciers melt. As this process continues and with growth rates compromised by corrosive waters, fewer reefs will be able to keep pace and maintain their position in sunlit shallows.

A third climate impact takes place on reefs at a microscopic level because if there's one thing zooxanthellae can't stand, it's warm water. When the temperature goes up by just a few degrees for a couple of months, zoox abandon their coral host, leaving behind a ghostly white skeleton. There's a chance the coral colony might survive a few weeks of bleaching and eventually take on board replacement sugar-producing lodgers. Usually they die. Mass coral bleaching events have swept across entire regions with increasing frequency and severity as sea temperatures have risen since the early 1980s. Warmer seas also seem to make corals more vulnerable to lethal diseases, which are already devastating reefs. The situation will only get worse.

Other threats to reefs take place at an ecosystems level. One of the most critical is overfishing. When entire groups of fish are stripped away they are sorely missed not just by visiting divers and snorkelers but also by the ecosystem. Their absence often triggers complex and unpredictable

cascades of change through a reef. Without large parrot fish to clear away dead coral and sediment, areas of reef can become smothered and inhospitable for new corals. Grazing fishes nibble down fleshy algae that outcompete reef-building corals—and some even respond instantly to chemical burglar alarms released by corals when algae touch them. Trawl nets, fish bombs, and cyanide pose additional threats to reefs, and despite being widely banned still rip up, blow apart, and poison reefs.

All of these problems, plus many more, add up to the chilling reality that most of the world's coral reefs are already at risk. Findings from the *Reefs at Risk Revisited* study in 2011 revealed that 75 percent of all coral reefs are now threatened by human activities. Looking into the future, that number is likely to go up starkly to 80 percent by 2030, and by 2050, if the world carries on with business as usual, 99 percent of coral reefs will be threatened.

To tackle these depressing statistics, scientists and conservationists already have a tool kit of measures to help protect oceans and coral reefs. Reducing global greenhouse gas emissions has to be a priority, and fishing industries need to be effectively and carefully managed. There are also conservation actions that can take place at more local levels. Marine protected areas safeguard parts of the ocean from many damaging human activities. Ideally they are strictly protected marine reserves like the great nature parks on land. They work especially well for areas of fixed habitat (such as coral reefs), and years of study have documented the flow of benefits from protected areas as tourist revenues grow and fish catches in nearby waters increase. Today, marine protected areas are still too few and far between and those that exist aren't always well enforced. Currently around 3 percent of the oceans are protected (to some degree), although that number is increasing year after year. Several vast marine reserves have recently been set up in remote coral reefs such as the Papahānaumokuākea Marine National Monument in the Pacific Ocean and the Chagos Islands in the Indian Ocean.

Smaller-scale reef conservation efforts include attempts to restore damaged areas or establish new habitats by creating so-called artificial reefs. These range from sunken ships and piles of rubble to precast ceramic modules that can be swiftly assembled on the seabed to mimic patches of natural habitat. A more high-tech approach involves passing electricity through metal wires shaped into reef-like forms; the current causes minerals to precipitate out of the seawater, forming a coral-attracting crust. Artificial reefs are commonly deployed to repair damage from ship groundings, to help stabilize areas of pulverized reef, and to promote coral settlement. Where dredging or construction (such

as laying pipelines and cables) is planned for reef areas, corals are sometimes removed from the path of destruction and fixed to artificial reefs elsewhere. There are even underwater cemeteries where people can have their cremated remains mixed with concrete and interred within the structure of an artificial reef.

HOW TO BUILD AN ARTIFICIAL REEF

Two key ideas lie behind the practice of making artificial reefs. First is the fact that lots of fish and invertebrates, such as lobsters and sea urchins, like to find places to hide. (Indeed, the earliest artificial reefs are thought to date back to the sixteenth century in Japan, when people threw bamboo logs onto the seabed to attract fish and boost their catches.) Then there is the tendency for marine larvae to stick to things—you only need to look at an old boat hull or a barnacle-encrusted whale to see how good they can be at clinging on.

A multitude of marine species cast their offspring into the water column to join the "larval rain" that flows through the oceans. Among the swarms of microscopic drifters are young algae, fish, crabs, shrimp, sponges, sea cucumbers, starfish, sea urchins, and corals. Around 75 percent of all known coral species are broadcast spawners, meaning they release eggs and sperm into the water column. Sometimes all the corals along a reef will release at the same time in a spectacular mass spawning event that looks like an upside-down snowstorm. When they bump into each other, eggs and sperm fuse to form tiny, free-swimming larvae that drift through the water column for up to a few months. In that time, depending on currents and tides, they can move hundreds of miles until hopefully they reach another reef and find patches of free space to settle onto. But this isn't a purely passive affair. Recent studies have shown that coral larvae can detect the popping, crackling sounds made by reefs dwellers. They zero in on this clamorous beacon, much of it uttered by thousands of snapping shrimp that burrow into the reef structure and can be heard from meters to kilometers away.

Once they have found a reef, various things determine whether or not coral larvae will fix themselves in place and transform into polyps. It often depends on what has arrived first. Large, fleshy algae tend to monopolize space and repel larvae. On the other hand, another form of algae helps coral colonies take hold. Coralline algae grow in thin, crusty layers, often in delicate pinks and oranges, and emit chemicals that coral larvae find irresistible. Some artificial reef projects have tried to mimic these substances and create chemical "flypaper" for corals. Other organisms suppress coralline algae, such as encrusting sponges, tunicates, bryozoans, and zoanthids. These rampant colonizers can smother surfaces in dense

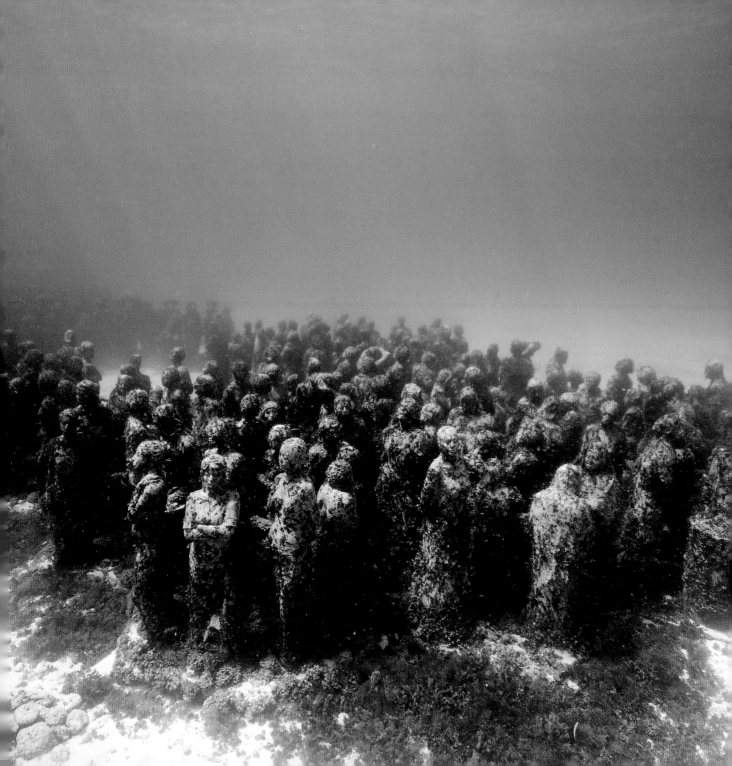

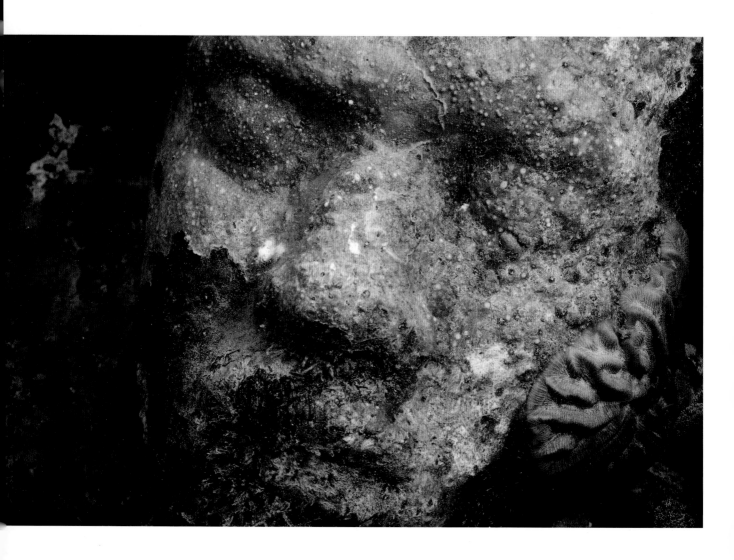

carpets and even kill young coral recruits that have already stuck to a reef.

Corals can also reproduce by budding off identical copies of themselves. People have learned to mimic this by snipping off nubbins of living coral, nurturing them in underwater nurseries, and then tying or gluing them in place on natural reefs that have lost coral cover or on new manmade structures. A popular approach that poses no additional pressure on natural reefs is for divers to gather storm-damaged coral fragments and rear them to a decent size before transplanting them. This is now being done at an immense scale in the Caribbean. Disease and other impacts have wiped out 90 percent of the two main reef-building coral species across the region. Conservationists are propagating tens of thousands of fragments of staghorn and elkhorn corals with the aim of kick-starting their convalescence in the wild.

For an artificial reef to be a biological success—for it to transform into a natural-looking, self-sustaining ecosystem—a profusion of species needs to move in. Each one has its part to play in the hustle and bustle of everyday life on a reef. Hard corals form the robust building blocks of a reef, coralline algae help consolidate the structure, and together they create habitat for more species to occupy. Branching corals and sponges shield the reef from blustery currents and offer shelter to other crea-

tures. Fish and invertebrates are drawn to secluded nooks where they hide from the many hungry predators that make reefs a dangerous place to linger in the open. And it is with all this in mind that Jason deCaires Taylor sets about designing his unique underwater sculptures.

TURNING ART INTO ARTIFICIAL REEFS

A key part of deCaires Taylor's work involves finding ways to make his sculptures as appealing to reef life as possible. First and foremost, they are made from pH-neutral, marine-grade cement free from any other substances, including metals, that could be harmful to marine life. Concrete and cement have proven to be the most suitable man-made substances to construct artificial reefs because coral larvae will readily settle on them. (A disastrous artificial reef was built in Florida in the 1970s from two million car tires, onto which not a single coral larva attached—chemicals in the rubber kept them at bay.) The cement deCaires Taylor uses is also highly durable and this means the sculptures will stand up to the harsh conditions they face on the seabed. The idea is that they will stay solid and firm for many years, if not decades, giving slow-growing corals plenty of time to create their own self-renewing edifices. In comparison, shipwrecks swiftly corrode and crumble away.

To encourage coral and other species to settle on them, deCaires Taylor leaves

areas of rough texture on his sculptures. This helps the minute larvae to get a grip. His designs also incorporate crevices and holes for reef dwellers to hide in. Some of these are inherent parts of his subjects. People and clothing offer plenty of shelter for small animals. Where dozens of human figures congregate on the seabed in deCaires Taylor's *The Silent Evolution*, their legs form inviting shelter for large schools of fish. The statues often have a cloud of snappers hovering over their heads, which then dart to safety when a snaggletoothed barracuda looms into view. Other animals find sanctuary deep inside some of deCaires Taylor's sculptures. Interior chambers form dark cubbyholes for lobsters and other shy reef residents to hide in.

The locations of deCaires Taylor's sculptures are carefully considered to give coral dwellers a good chance of finding them. Where possible they are placed downstream of healthy reefs to intercept the all-important flow of larvae. The Manchones reef system in Mexico not only provides a source of larvae for *The Silent Evolution* sculptures but also shelters them from tropical storms. Timing is crucial too. Mass coral spawnings tune into lunar cycles and send out fairly predictable pulses of larvae. When sculptures are deployed just before one of these events, they are more likely to acquire a new generation of coral before other species, such as large algae,

have a chance to take over. For some of his pieces, including *The Gardener* and *Holy Man*, deCaires Taylor has sped up coral growth by fixing storm-damaged nubbins and nursery-reared fragments to the sculptures.

One of the key conservation benefits of artificial reefs in general, and deCaires Taylor's underwater sculptures in particular, is relieving the pressure of tourism on natural reefs. Income generated by reef-based tourism can no doubt encourage coastal communities to look after their reefs. But visitors to these areas inadvertently damage the very ecosystems they come to see. Clumsy scuba divers and snorkelers accidentally whack and break corals, not only directly injuring them but also making them potentially more susceptible to disease and algal overgrowth. Artificial reefs, in various guises, are deployed to help divert the flow of diving traffic away from natural reefs. DeCaires Taylor's sculptures at Punta Nizuc in Cancún are located a short swim from one of the world's busiest snorkel sites. Each day around five hundred people visit the shallow reef, many of them inexperienced divers who are more likely to touch, climb on, or accidentally kick the coral. DeCaires Taylor's underwater sculptures help to encourage visitors to spend at least half their time in the water away from the areas of brittle, natural reef. However, one possible drawback of deCaires Taylor's sculptures is that they could be too

successful and attract more visitors to these areas than before. To avoid increasing the overall pressure of tourism on reefs—both natural and artificial—it helps to educate tourists about the impacts they have and encourage them not to touch or trample.

By building new habitat in featureless stretches of seabed, artificial reefs can help boost biological diversity in local areas that might otherwise hold little interest for underwater visitors. DeCaires Taylor's *The Silent Evolution* was installed in a patch of sand five hundred meters from other reefs. Previously there were no marine species to speak of and now the cluster of vibrant structures is smothered in life. After three years on the seabed, more than fifty species have been spotted in and around the sculptures, including fish, lobsters, crabs, sponges, algae, and coral.

Beyond the benefits of growing new habitat and tempting tourists away from fragile reefs, deCaires Taylor's creative experiments are also helping to show how coral reef ecosystems work. By uncovering some of the complex, capricious forces that govern life in the sea, artificial reefs help scientists understand more about reef ecology. They illuminate the interactions between species, the fluctuations, and the pace of change as nubbins of coral flourish into dense thickets. Some of deCaires Taylor's sculptures in Mexico have become covered

in thick mats of algae. The most likely culprits are the influx of nutrient pollutants from land and the overfishing of grazers like parrot fish—factors that impact many reefs around the world. Surprisingly, where divers have tried removing patches of algae from the sculptures, they have often grown back worse than before; in areas left alone, the algae has disappeared. As the sculptures with their living cloaks continue to shift and reshape over time, they reveal glimpses of the many ecological puzzles that still remain in the oceans.

One aspect of coral ecology that deCaires Taylor's work is tracking for the first time is the evolving soundscape of a new reef. Marine biologist Heather Spence suggested DeCaires Taylor turn one of his sculptures into a giant listening station. The outcome is *The Listener*, a human figure covered in ears, modeled on a group of schoolchildren. Inside the structure is an electronic listening device that records thirty seconds of ambient sound every fifteen minutes. Never before has the shifting noise print of a new reef been monitored from its inception. *The Listener* is listening to itself as marine life moves in and kindles an aquatic hubbub that will attract more larvae as they hunt for somewhere to live. The results of deCaires Taylor and Spence's listening experiment will no doubt be fascinating.

INSPIRING CHANGE

For most people, most of the time, the oceans are out of sight and out of mind. Steering popular opinion in favor of this neglected realm is one of the greatest challenges facing marine conservation today. On their own, the facts of environmental decline can be difficult to digest, especially when life as we know it carries on normally around us. There are still fishes on supermarket shelves; seas don't rise so fast that we notice; not a lot seems to change.

Collaborations between scientists and artists can help engender a more emotive response to nature's troubles, to spark interest and inspire action. By bringing visitors to see his underwater museum, both in person and through images of his works, deCaires Taylor is helping to persuade a broad audience to care about ocean life. Because like all great art galleries, his work makes people think. The striking beauty and incongruous scenes he builds on the seabed are instantly appealing: a perfect ring of people holding hands; a man sitting at a desk gazing at an old-fashioned typewriter. Then, as you look closer, there are powerful environmental messages woven throughout his sculptures that underscore the many problems the seas face today. A table laid with scrawny fish skeletons and a bowl of hand grenades tells of the overfishing crisis and how the oceans are being emptied to satisfy global greed. A collection of mines and bombs shows how time is fast running out to reverse reef decline and fix climate change. A fat man slumps in front of a TV, highlighting the apathy many people have toward issues outside their everyday lives. But among these stark scenes lie messages of hope. *Reclamation* depicts a woman, kneeling on the seabed, reaching skyward with lacelike wings gently sweeping to and fro in the underwater breeze. Her angelic wings are made from gorgonian sea fans, rescued after a storm. They show how beautiful things can emerge from disaster, how there is hope for rebuilding and restoring natural wonders. DeCaires Taylor's underwater museum reveals how ocean life is vulnerable and sometimes erratic. What's more, it shows us that nature has immense powers to regrow and recover, if we just give it a chance.

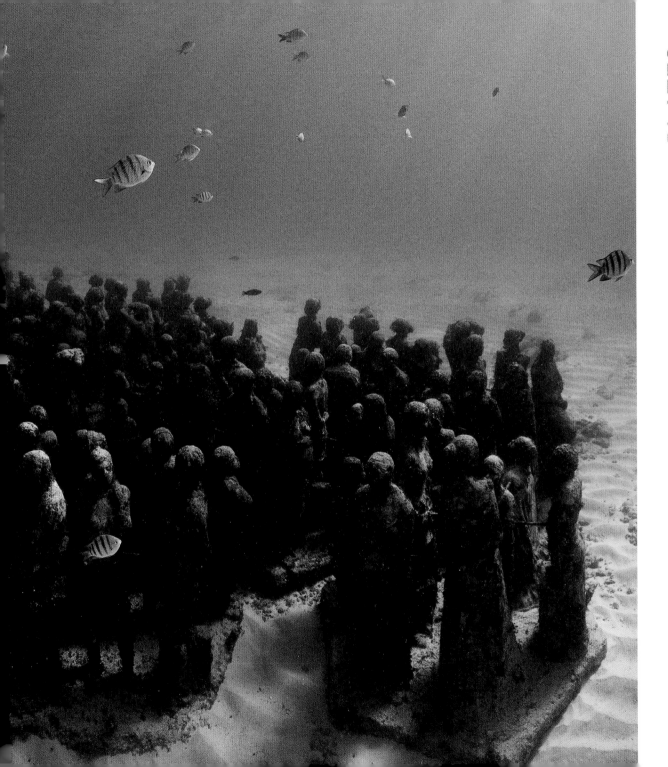

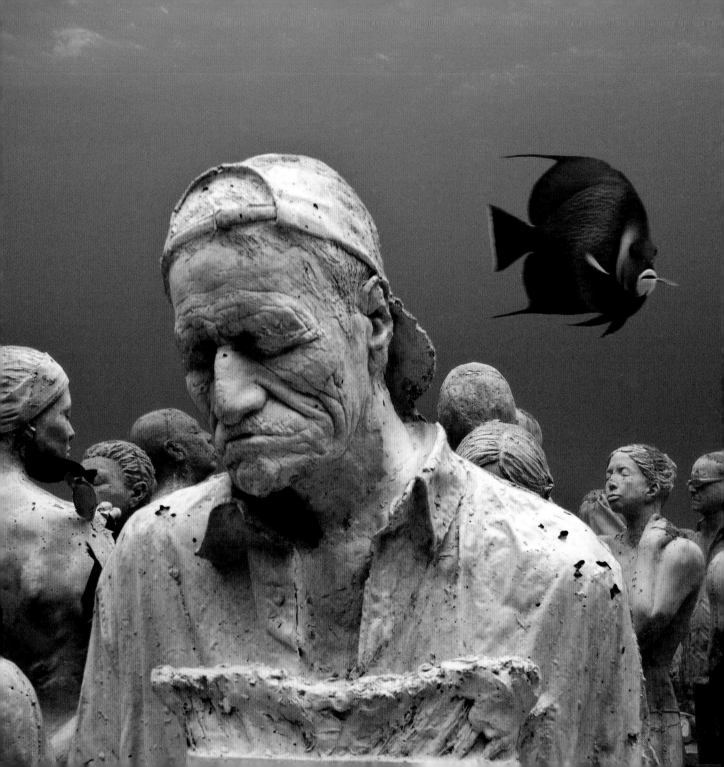

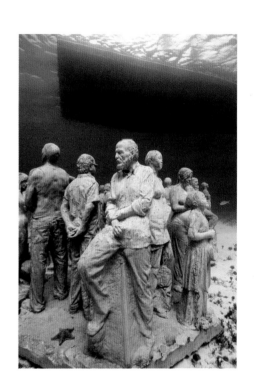

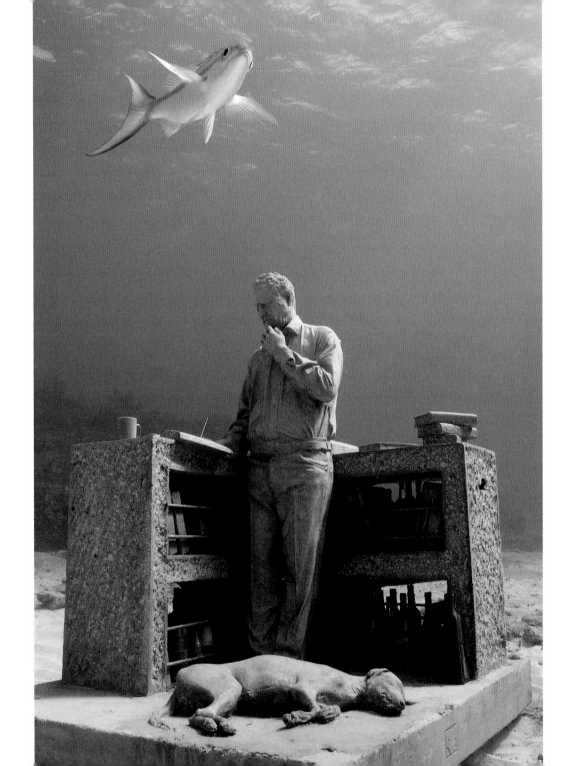

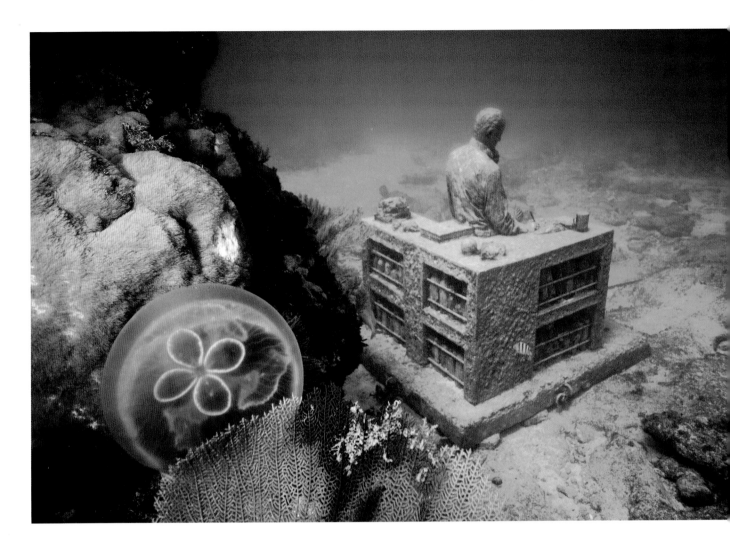

The Dream Collector archives a collection of messages in glass bottles that were collated by the artist from various communities around the world.

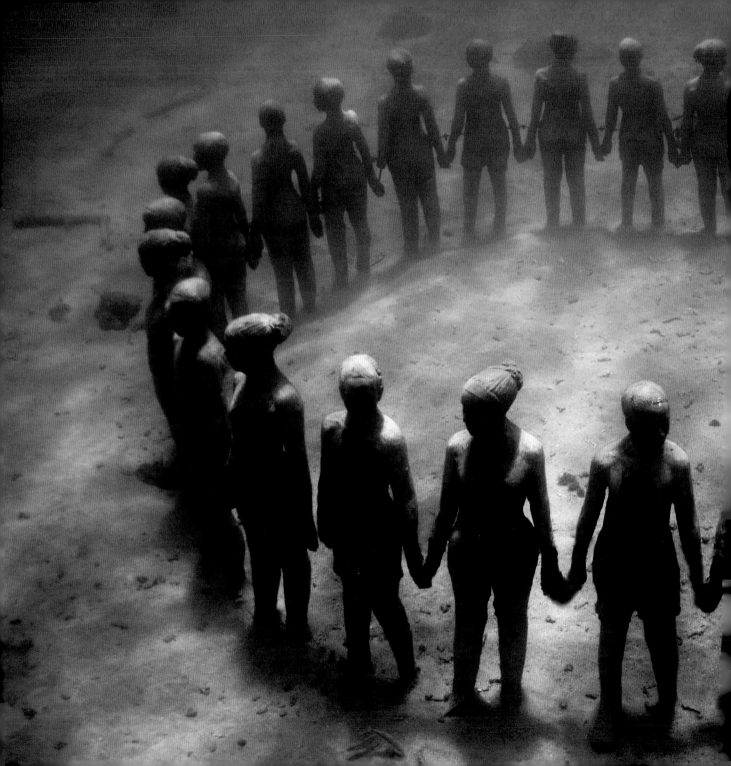

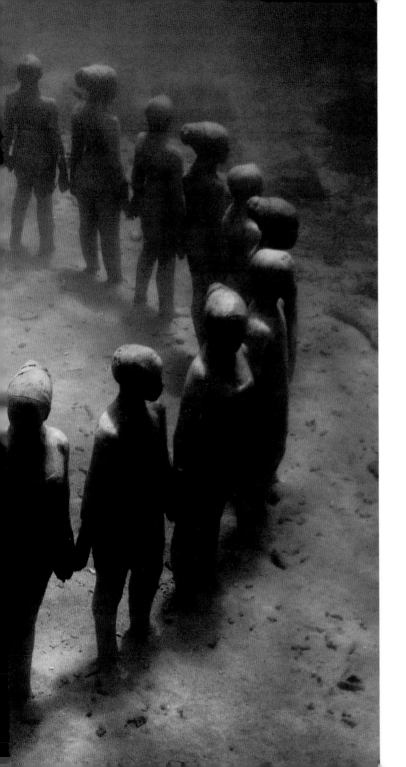

The mirror-finished piano in *The Musician* is based on an actual-size replica of a Steinway Concert Grand and incorporates spaces that are designed to encourage habitation by marine species. A small hermit crab can be seen crawling across the keys.

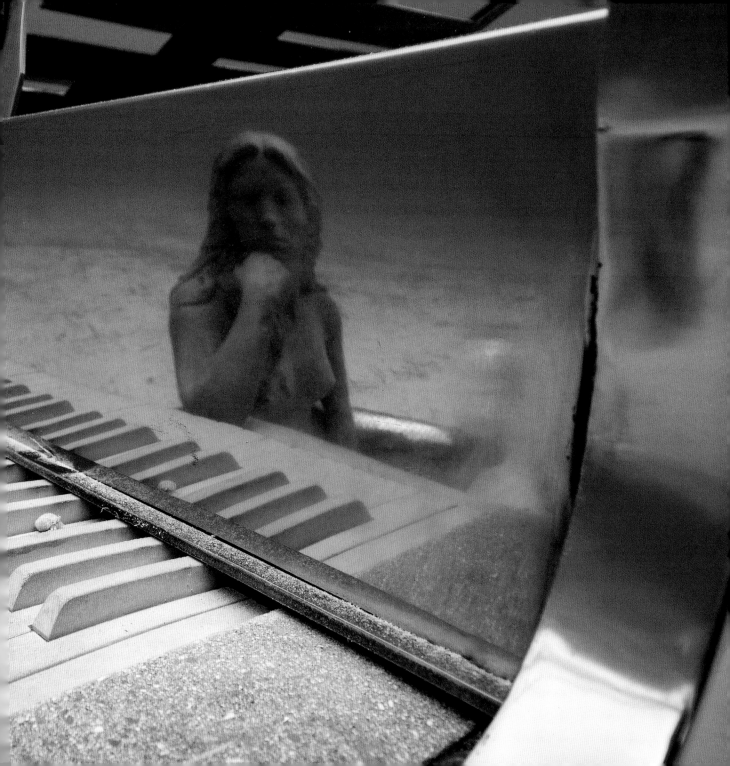

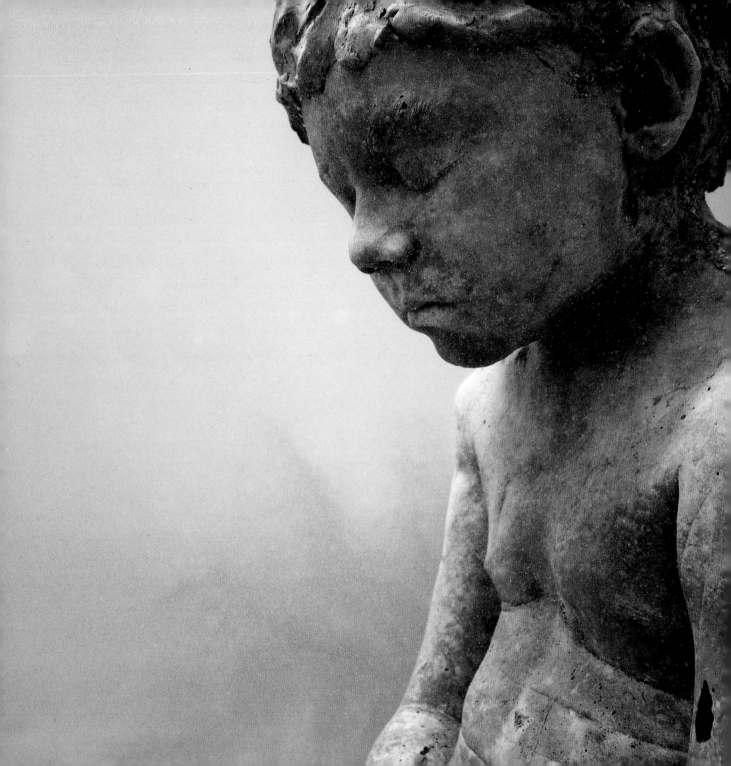

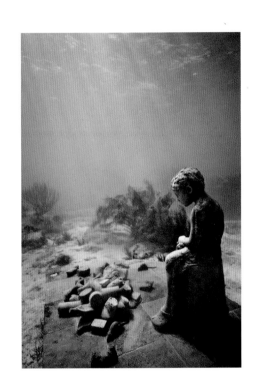

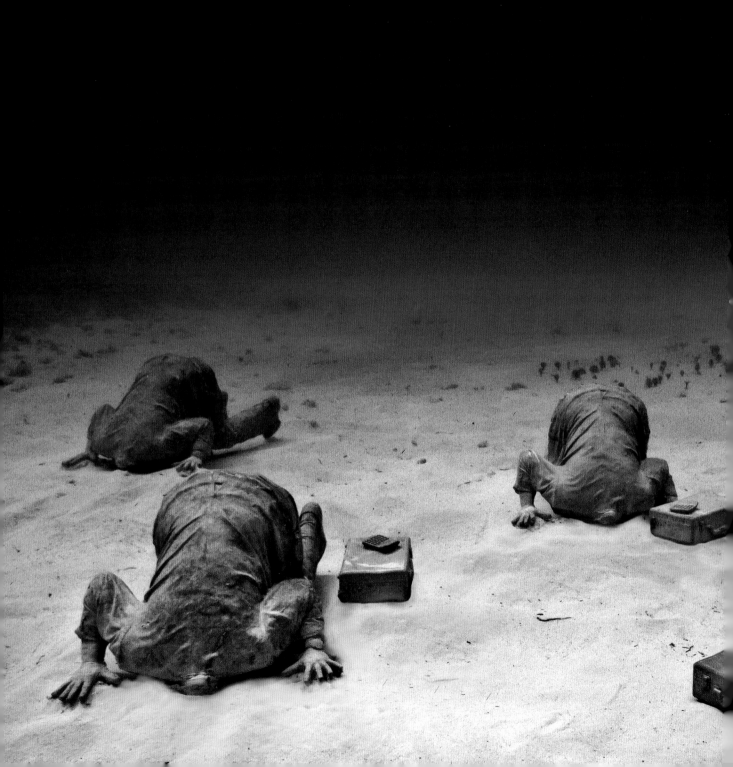

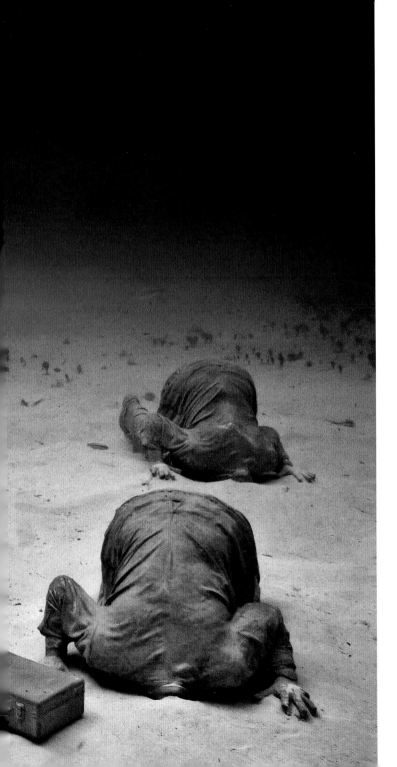

The Bankers symbolize denial, a resistance to acknowledge our looming environmental crisis, and the shortsighted actions of banking and government institutions. The identical positioning of the figures in a prayer-like pose also aims to highlight a shift in values—the replacement of idealism with a misplaced emphasis on monetary remuneration. The buttocks support an internal living space for crustaceans and juvenile fish to breed and inhabit.

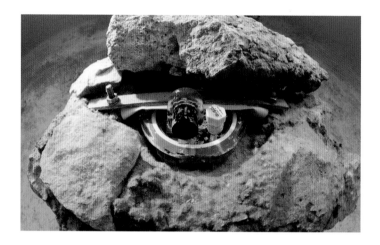

Assembled entirely from casts of human ears molded during a workshop of local Cancún students, *The Listener* is constantly recording the marine environment to advance our understanding of acoustic relationships while informing the science of conservation management.

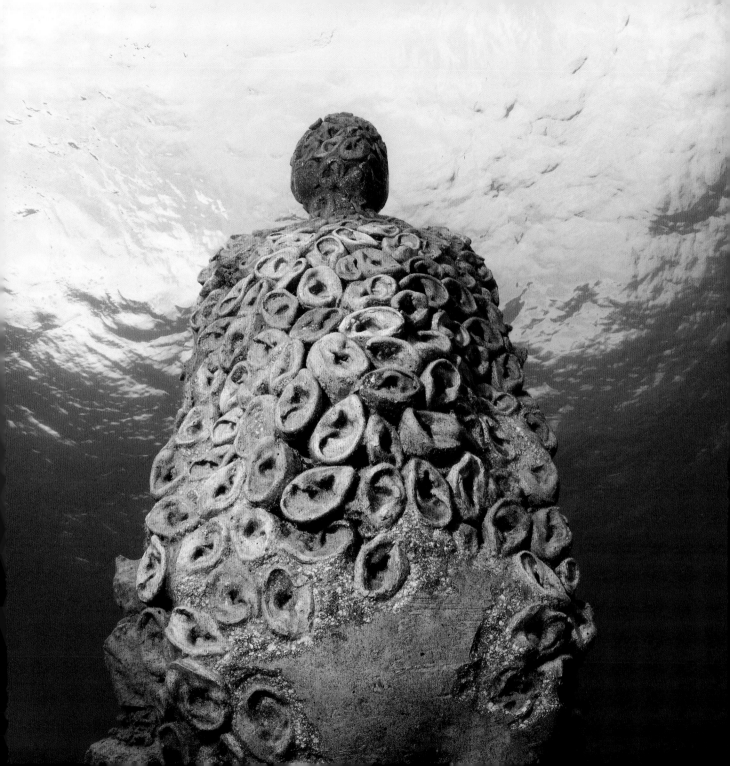

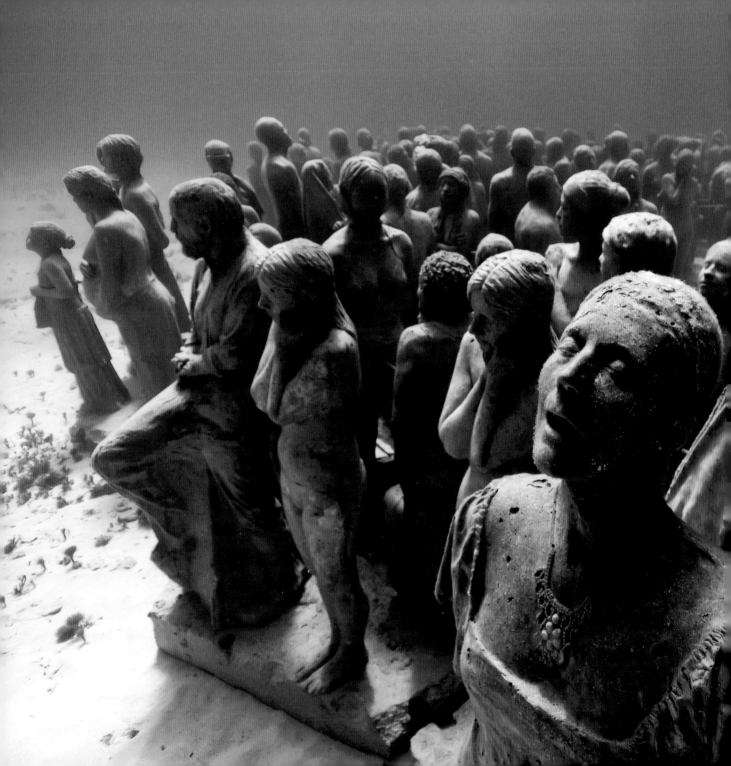

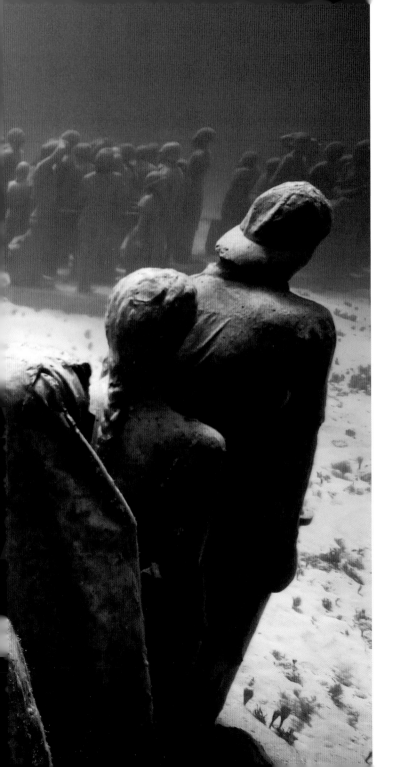

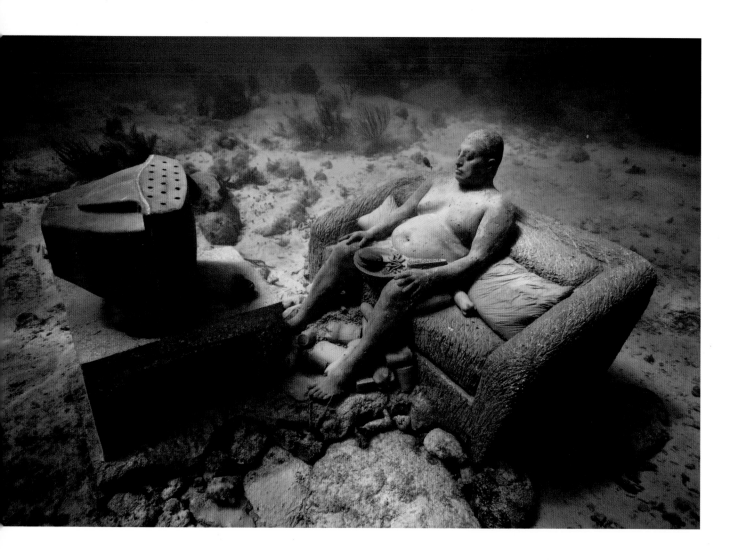

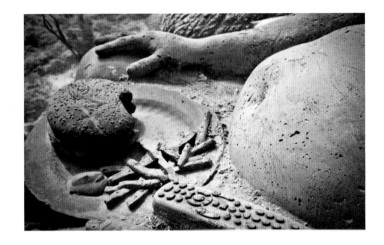

Inertia aims to show the human ability to live within a bubble. This tunnel-vision piece aims to immortalize our general apathy toward global warming.

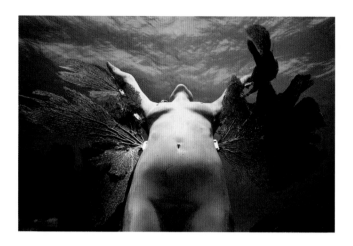

A celebration of rejuvenation, the wings of the angelic figure in *Reclamation* are planted with reclaimed purple gorgonian sea fans that had been displaced from the natural reef after heavy storm surges. The plant's mesh-like structure filters nutrients from the tidal currents.

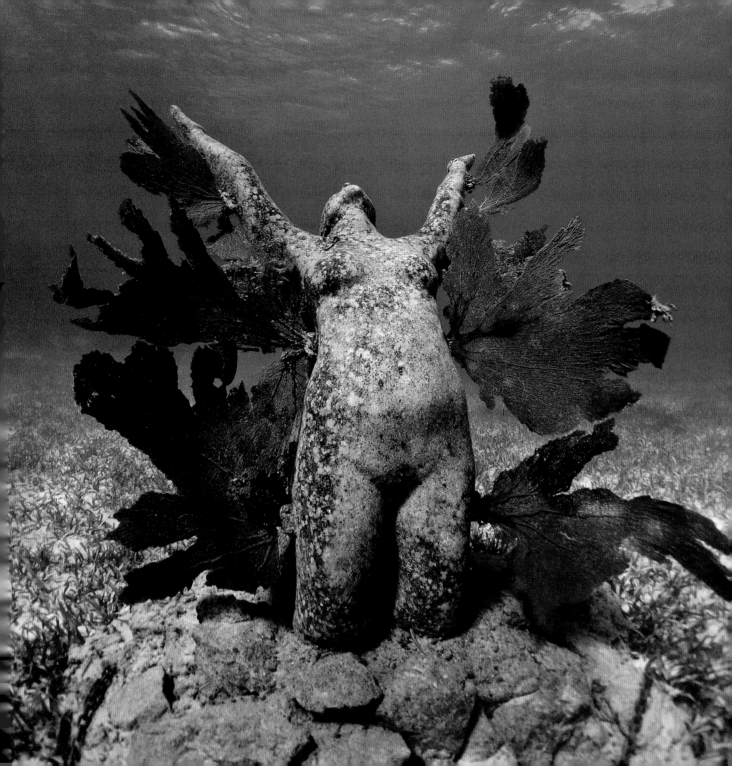

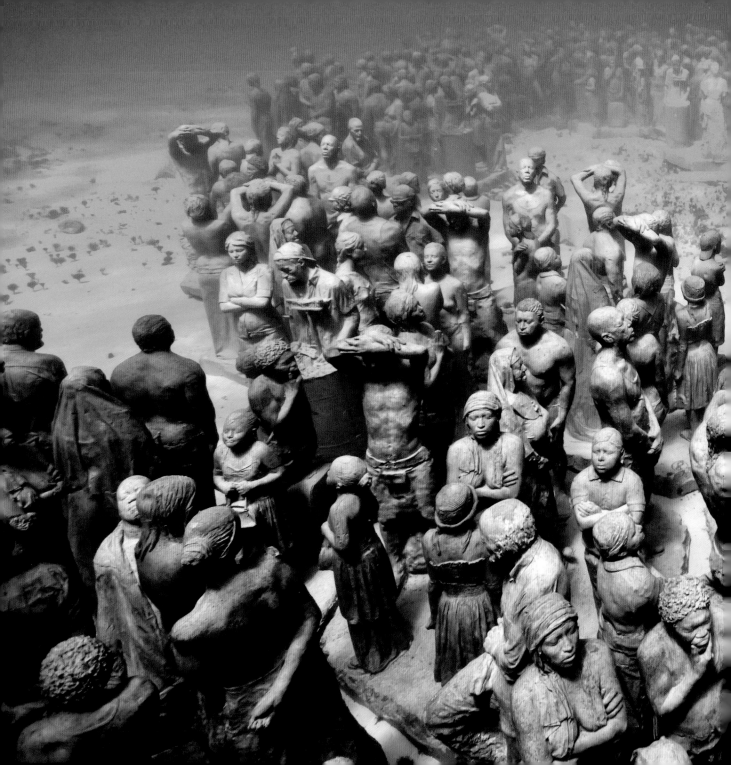

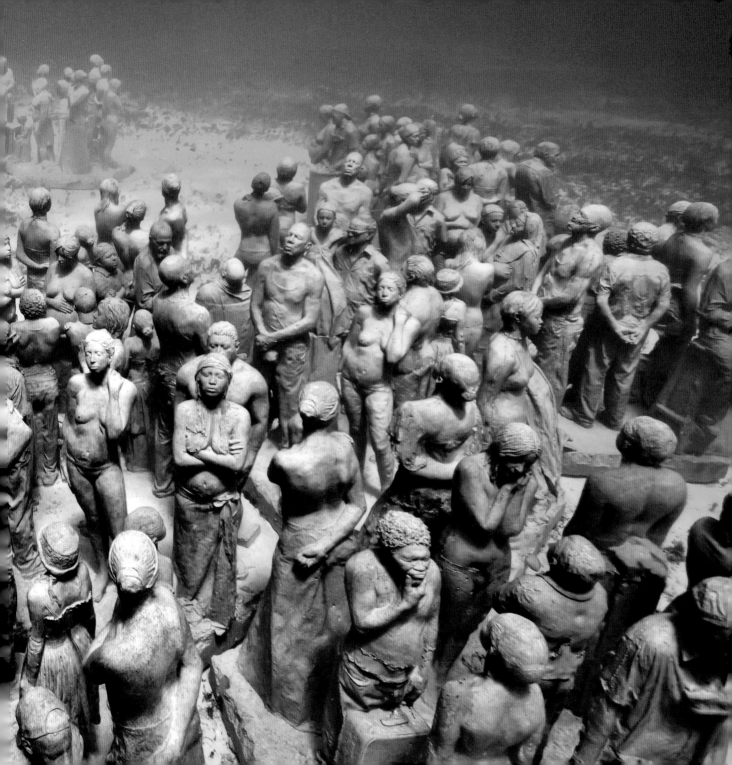

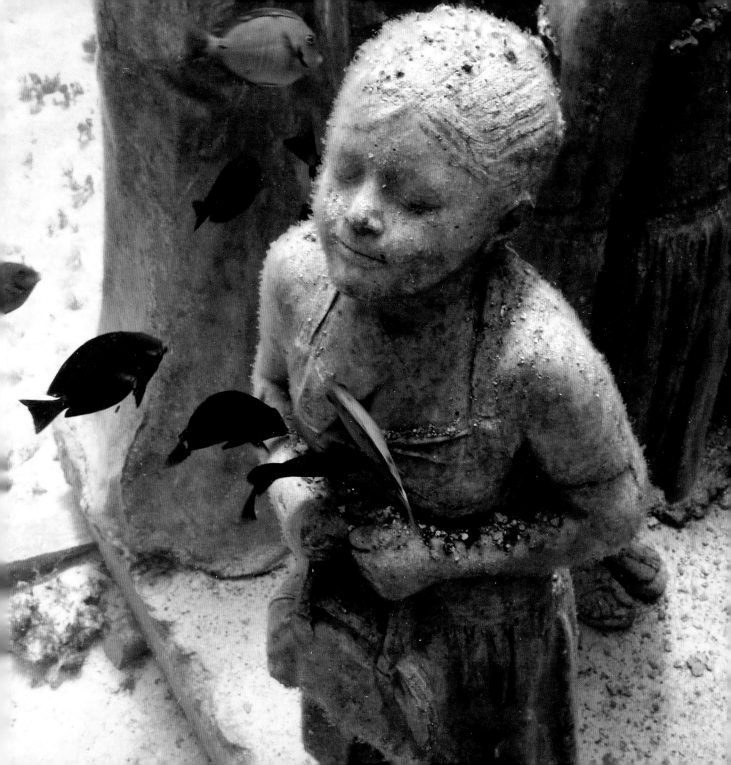

Symbolically representing the cycle of life, the children comprising *Vicissitudes* echo how we are all affected and transformed by circumstances, opportunities, and local surroundings, and how these changes begin to inscribe themselves within the physical body. Using young people for the artwork highlights the capacity of humans to adapt to their environment but also brings to attention the importance of attending to the future of that environment.

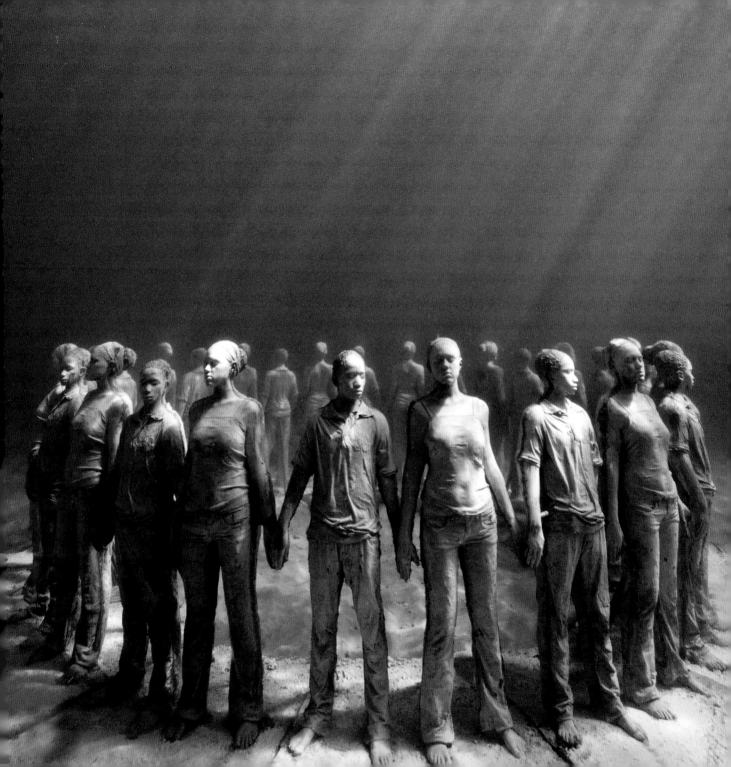

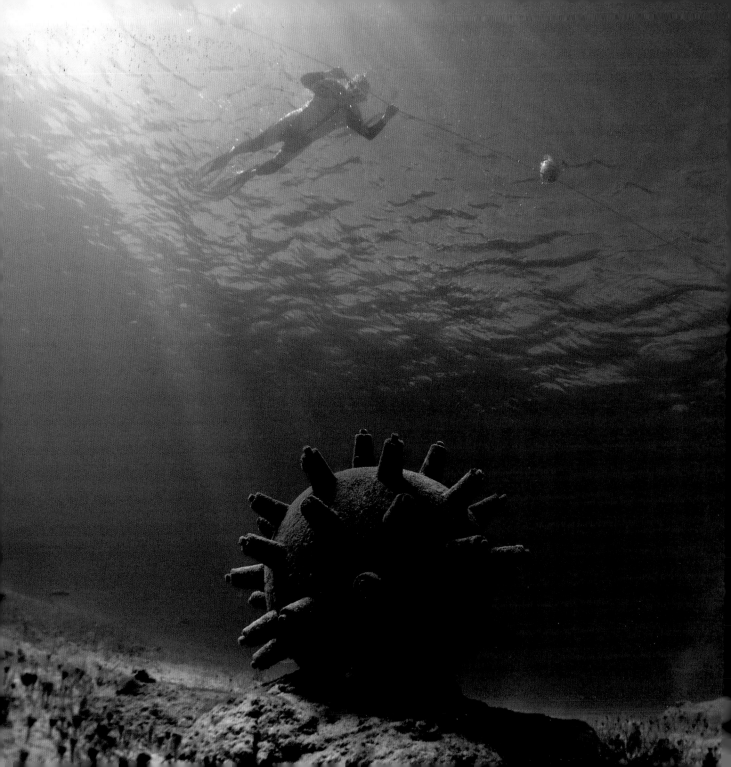

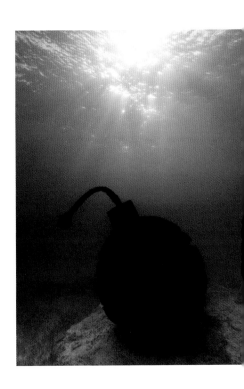

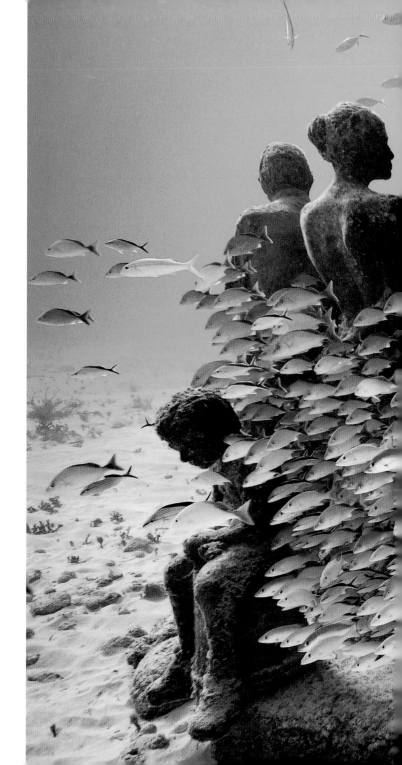

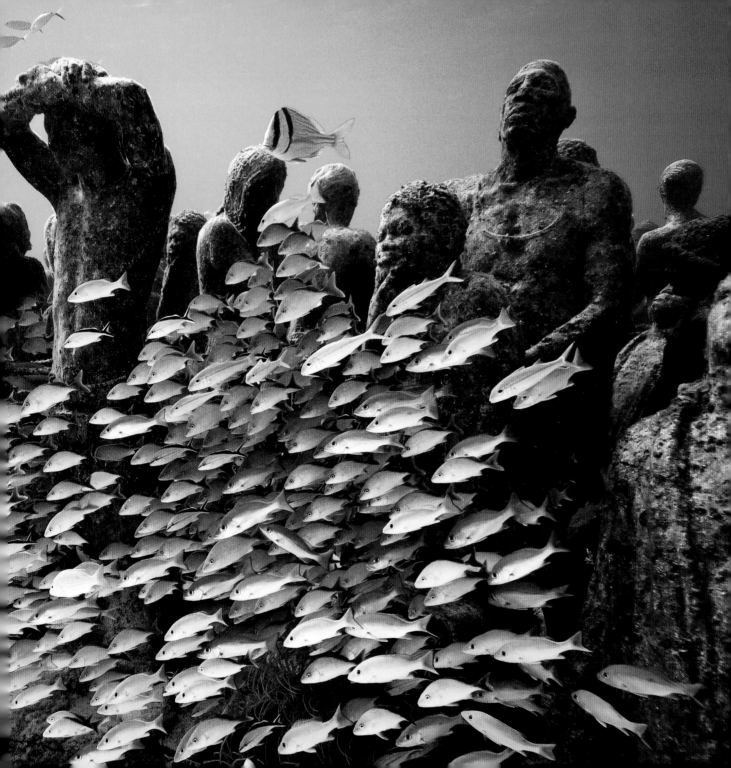

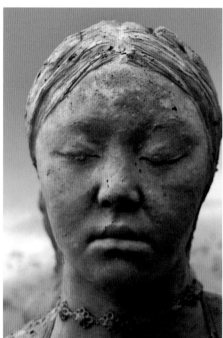

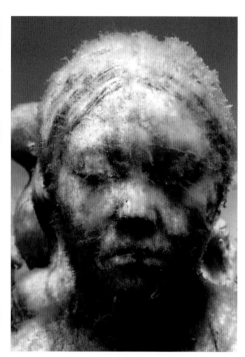

The first marine life to settle on *Grace*, part of *The Silent Evolution*, is a fuzzy layer of turf algae. This then disappears, perhaps nibbled down by grazing fish, and is followed by patches of orange and pink coralline algae. Eventually her features are lost beneath layers of encrusting coral and sprouting tufts of fleshy algae.

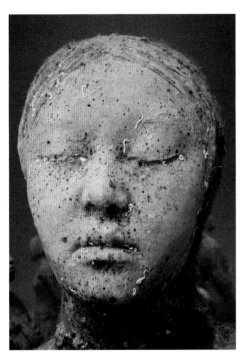
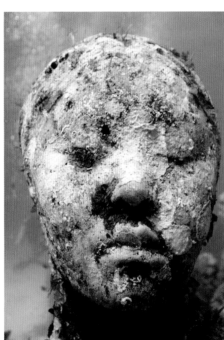
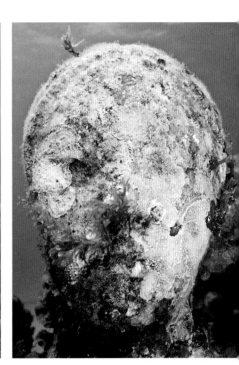

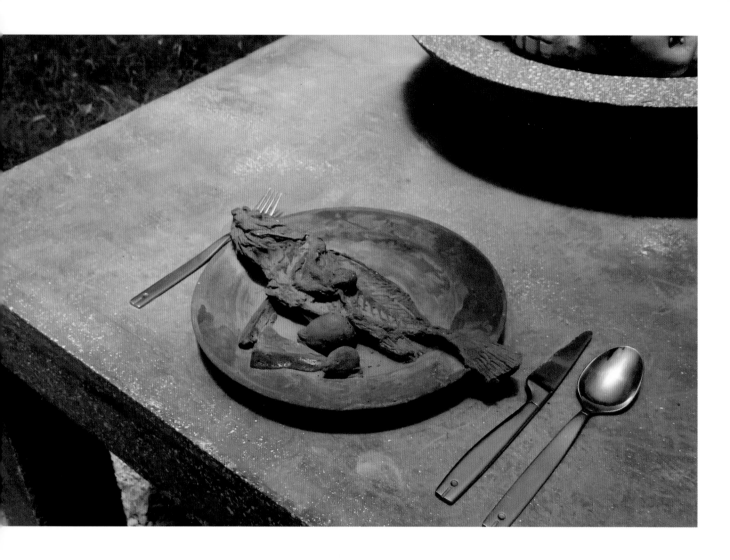

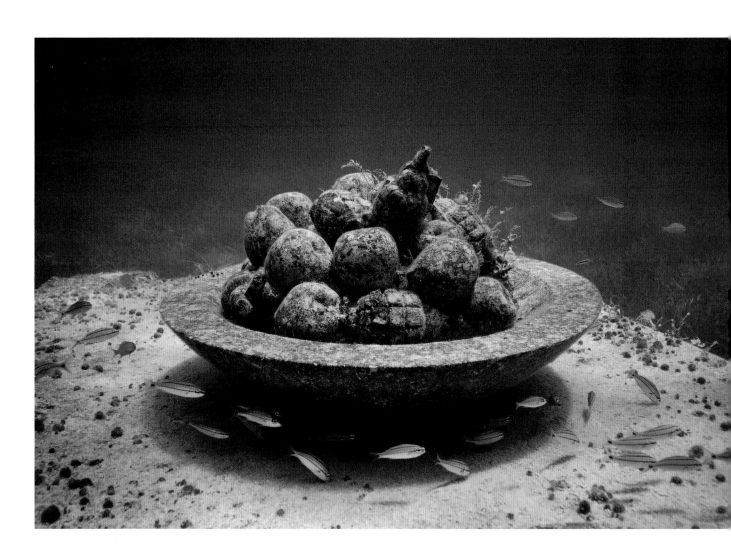

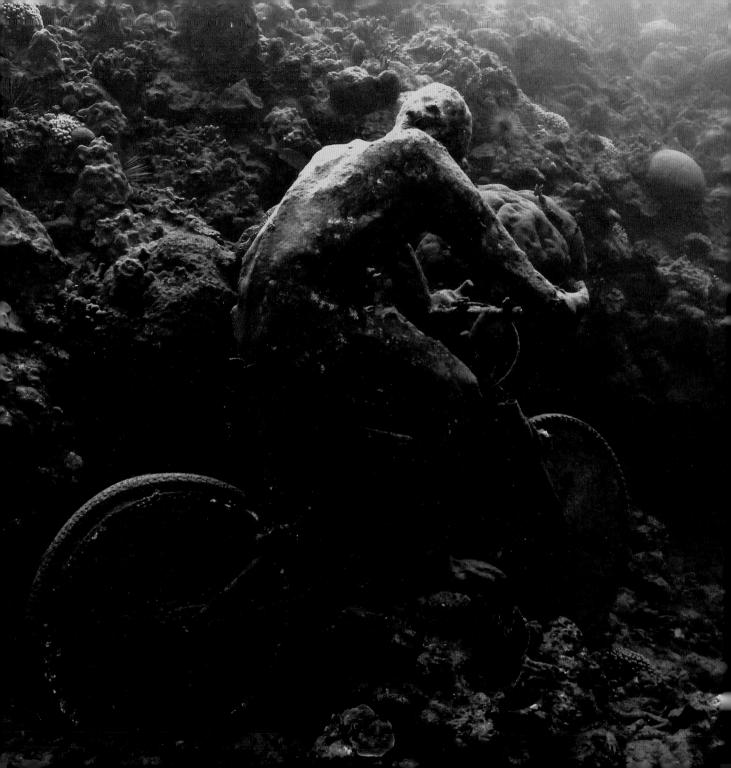

The last in the Grenadian series, in *Fall from Grace,* the lone cyclist—representing symbiosis and balance—aims to amalgamate himself into the reef.

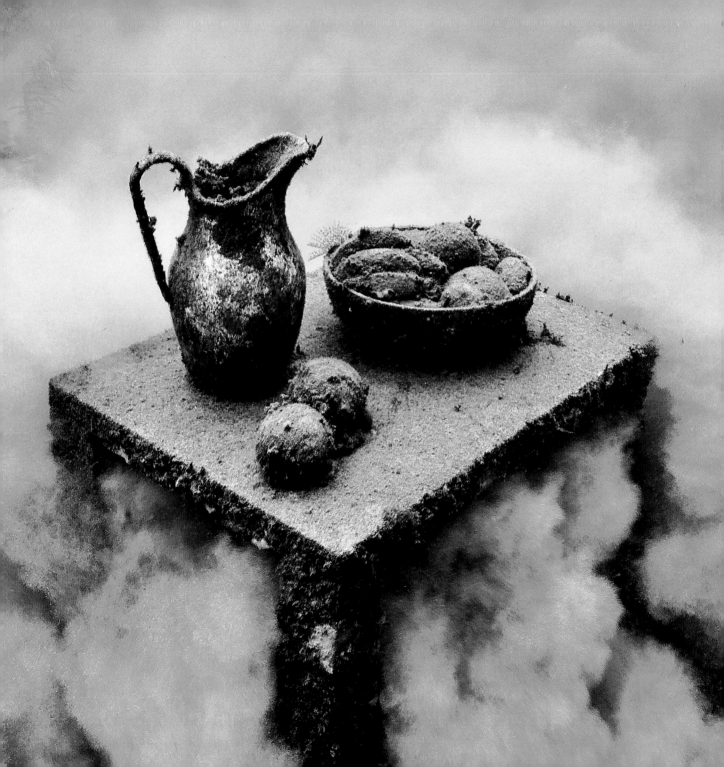

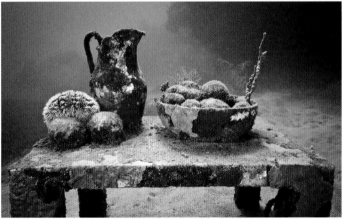

Following five years on the seabed, the *Un-Still Life* has become encrusted in marine life. The table is decorated in a fuzzy layer of turf algae, layers of pink encrusting sponges, and brown coral colonies. Patches of bright red encrusting sponge have grown on the jug and fruit bowl. A sea urchin ambles along, looking like a spiny piece of fruit. A finger of sponge pokes up from the fruit bowl, together with a colony of fire coral and a feather duster worm.

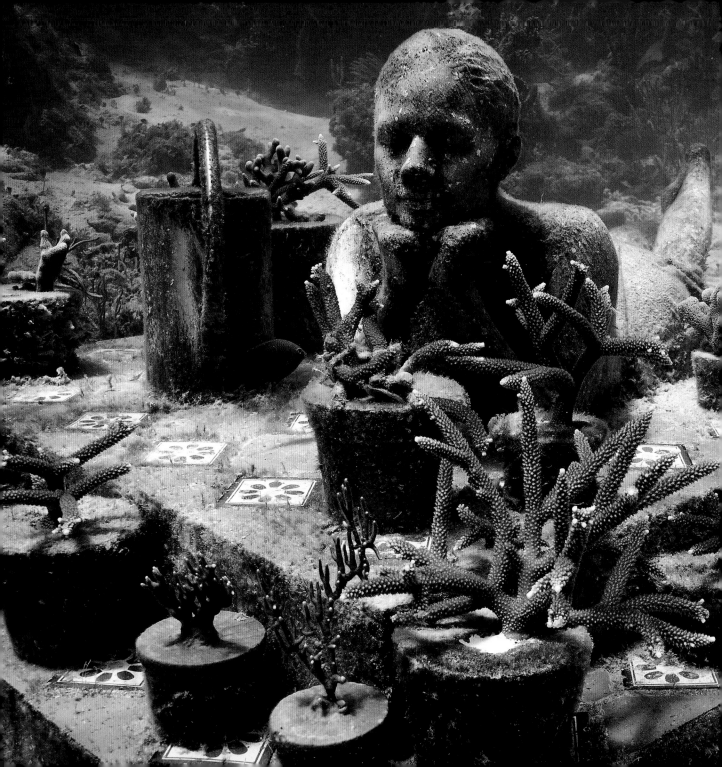

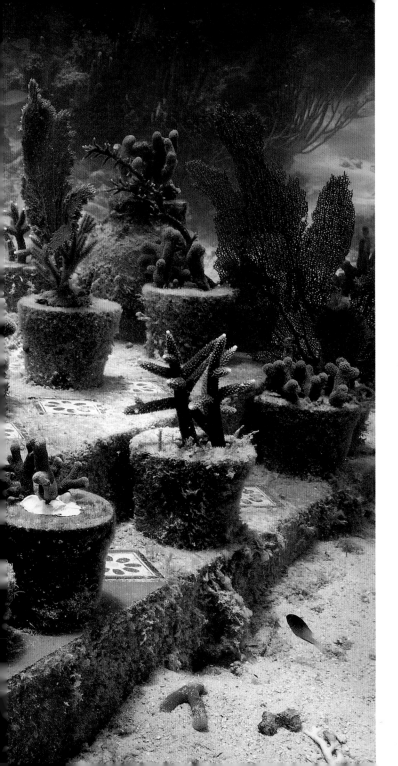

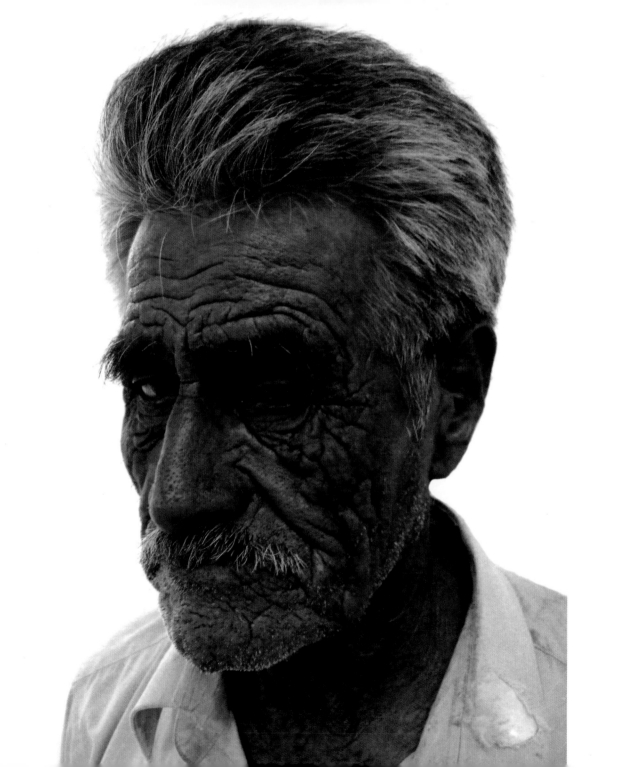

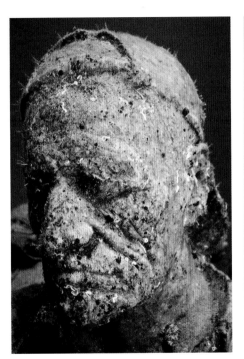
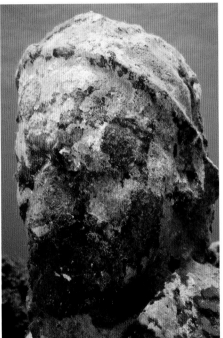

Against the blue backdrop of the ocean you can see the fine halo of stinging hydroids that first settle this statue of Leocadio Rodriguez Garcia. They are followed by red and pink blotches of coralline algae and brown coral colonies that eventually establish after three years and cover up his features.

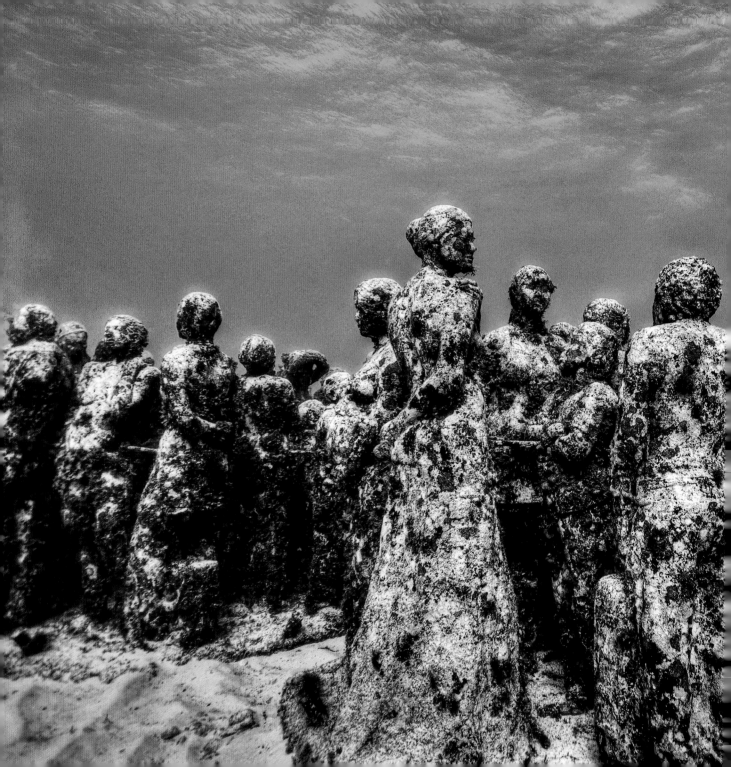

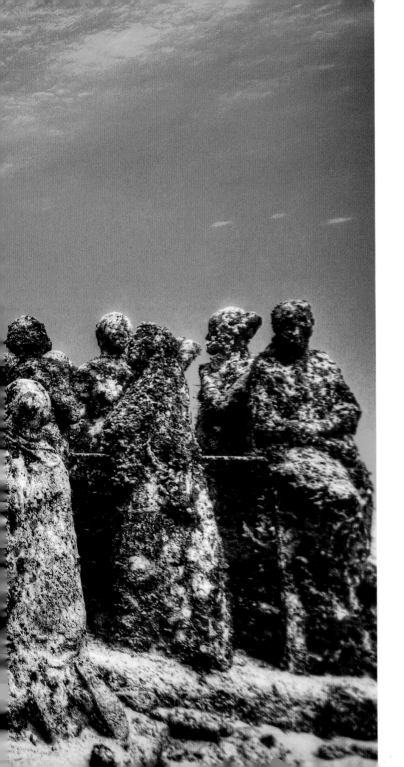

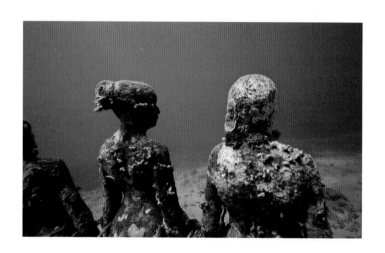

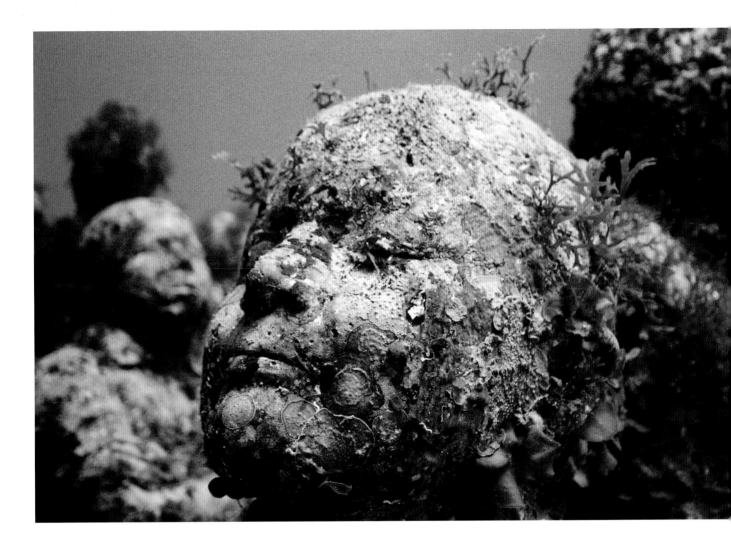

Valeria Ramirez, age eight at the time this sculpture was made, managed to keep completely still while clutching a small handbag and maintaining a slight smile on her face throughout the fifty minute lifecasting process.

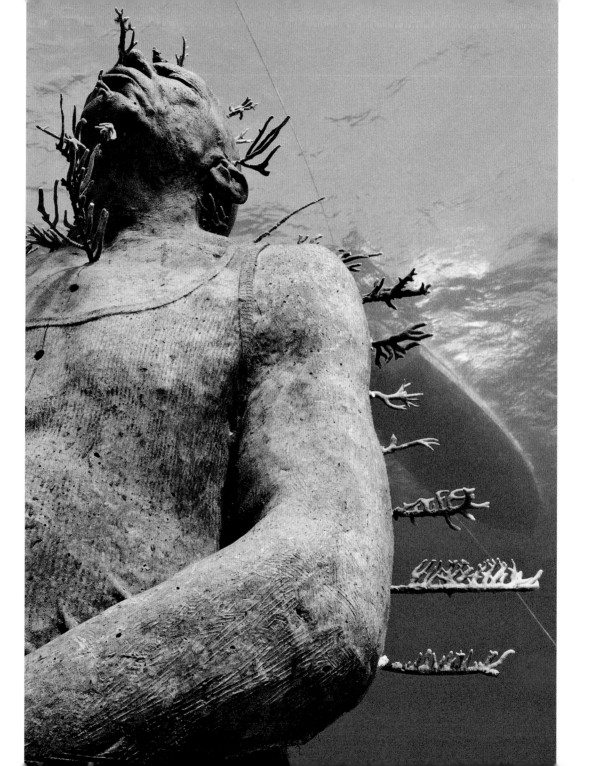

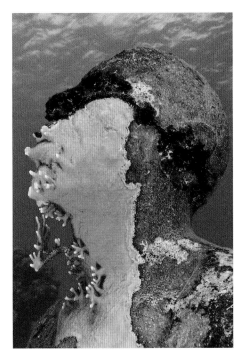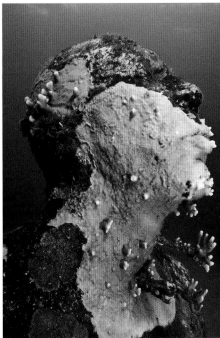

Man on Fire is seeded with rescued pieces of fire coral, which gains its name from its obvious bright orange appearance, but also because of its ability to inflict severe burns or stings to bare skin. The dominant species is able to repel many other types of marine growth and was installed using long-nosed pliers and marine epoxy adhesive.

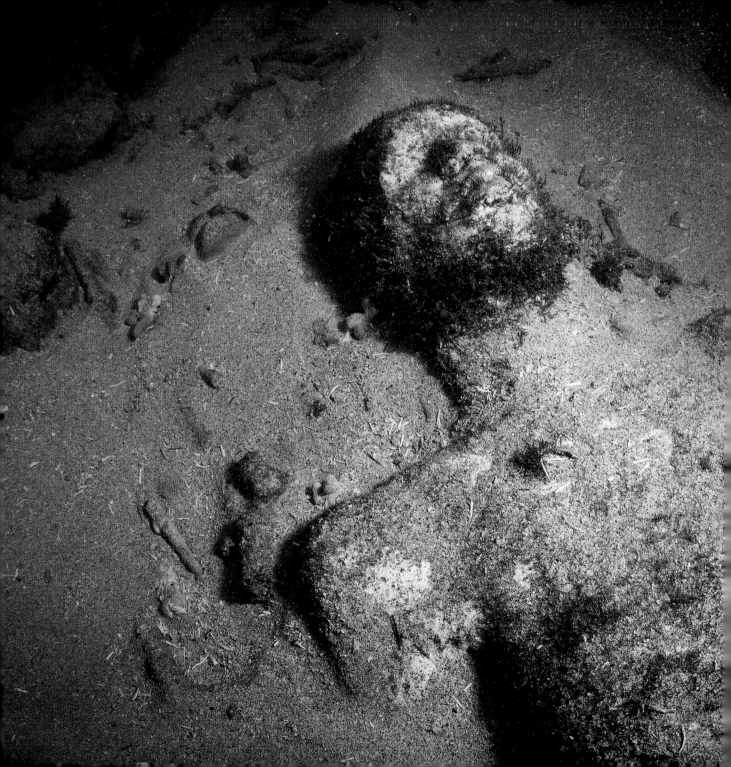

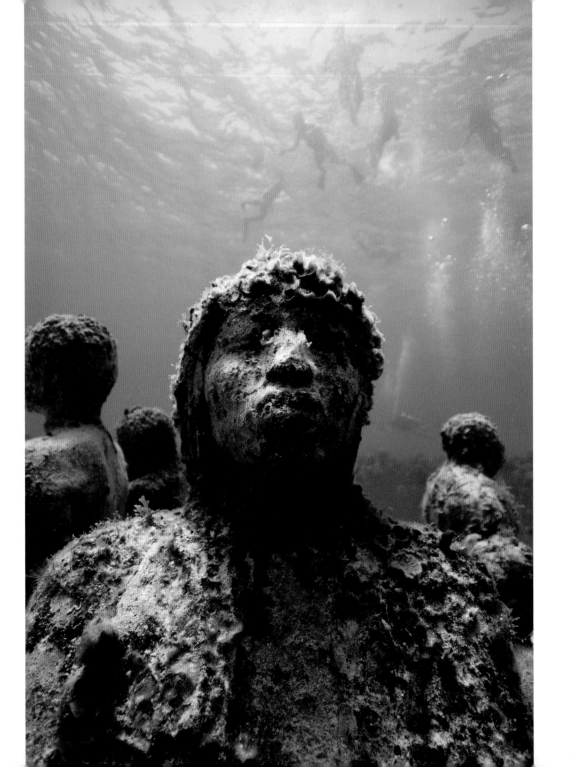

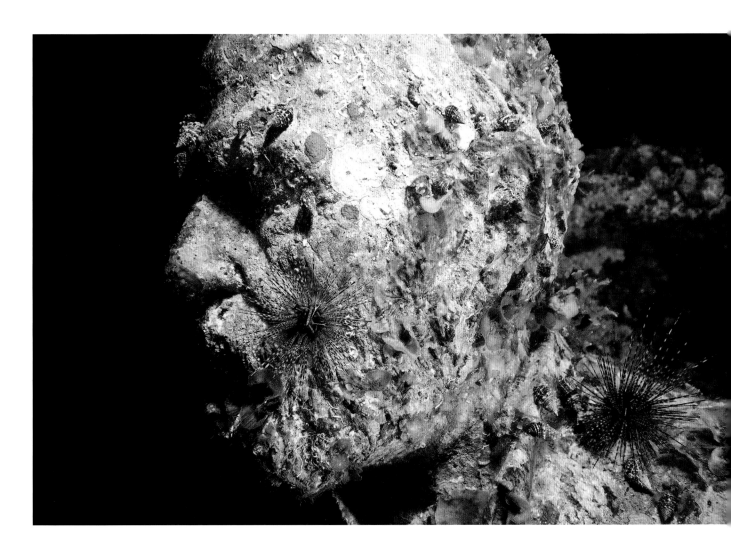

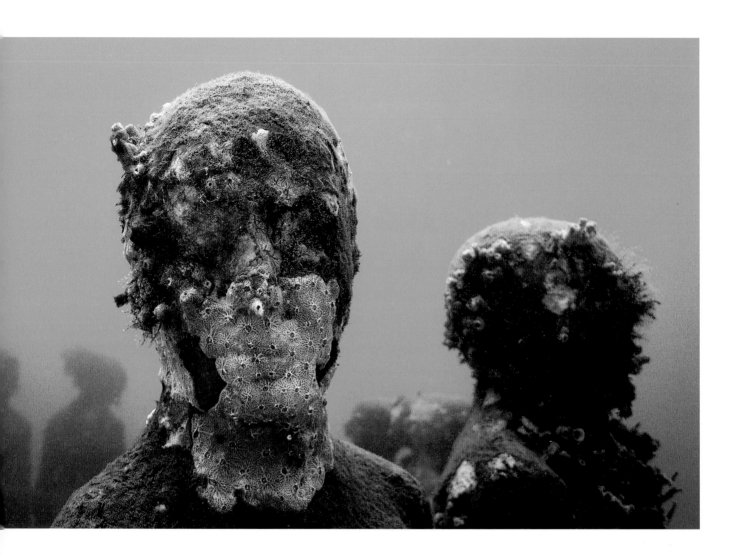

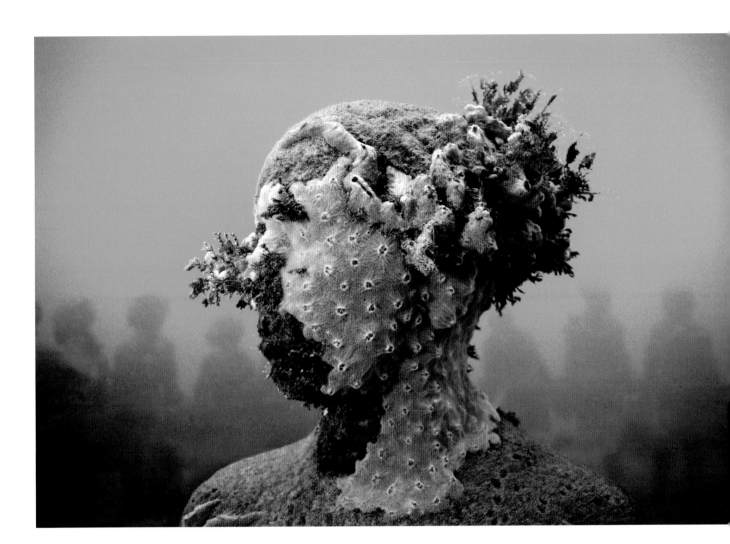

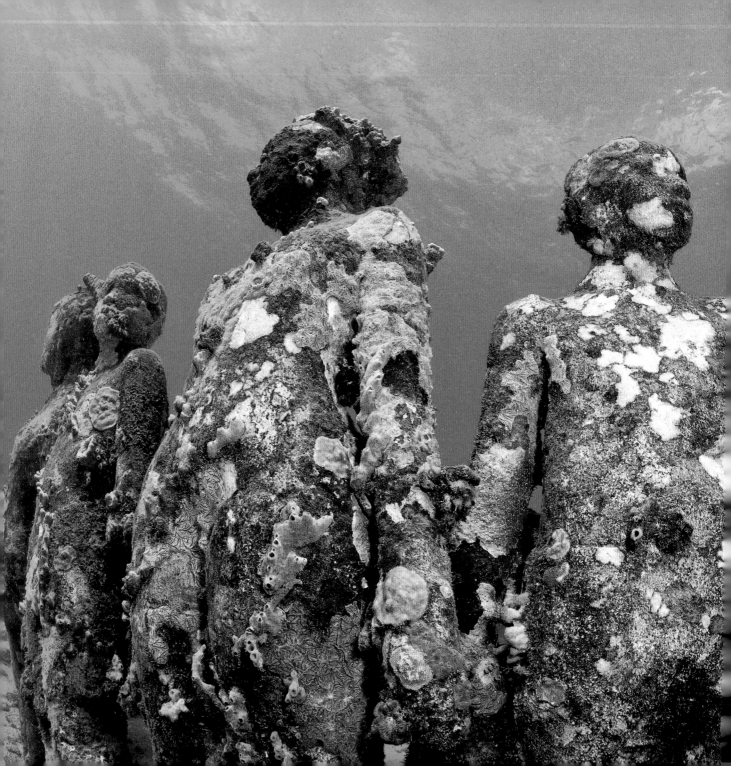

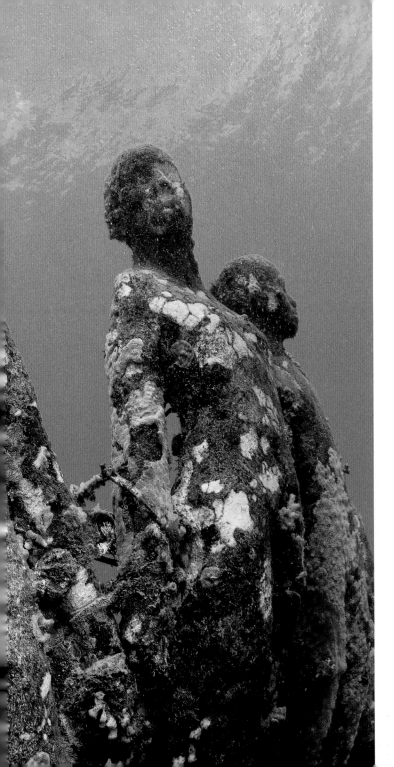

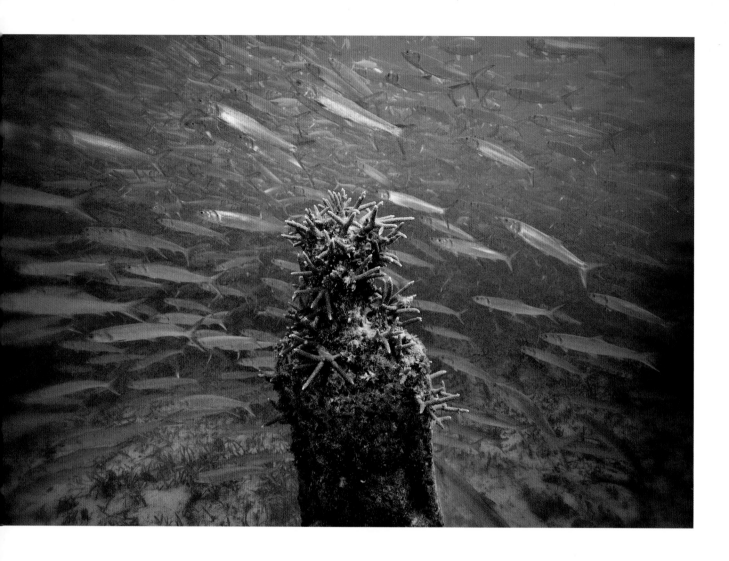

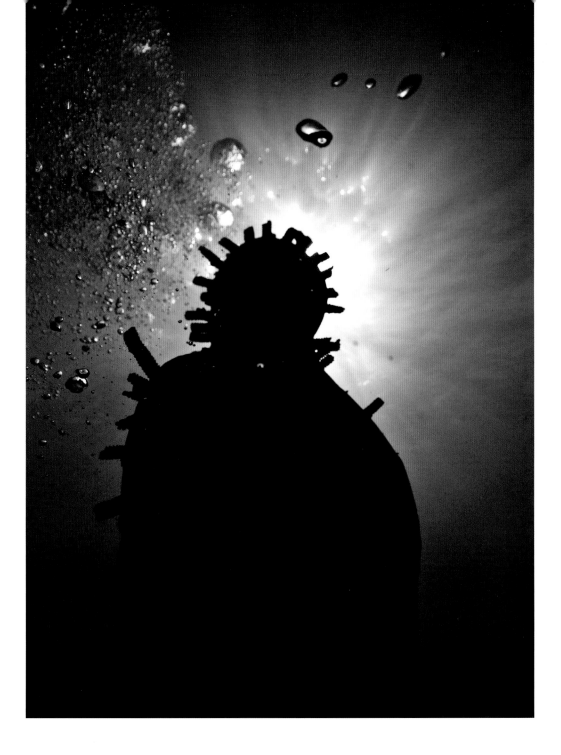

The soft purple sponge growth dominating the
face of this statue, part of *The Silent Evolution*,
survives by pumping and filtering water
through its networks of capillaries and arteries,
referencing the veins and transportation systems
of living human anatomy.

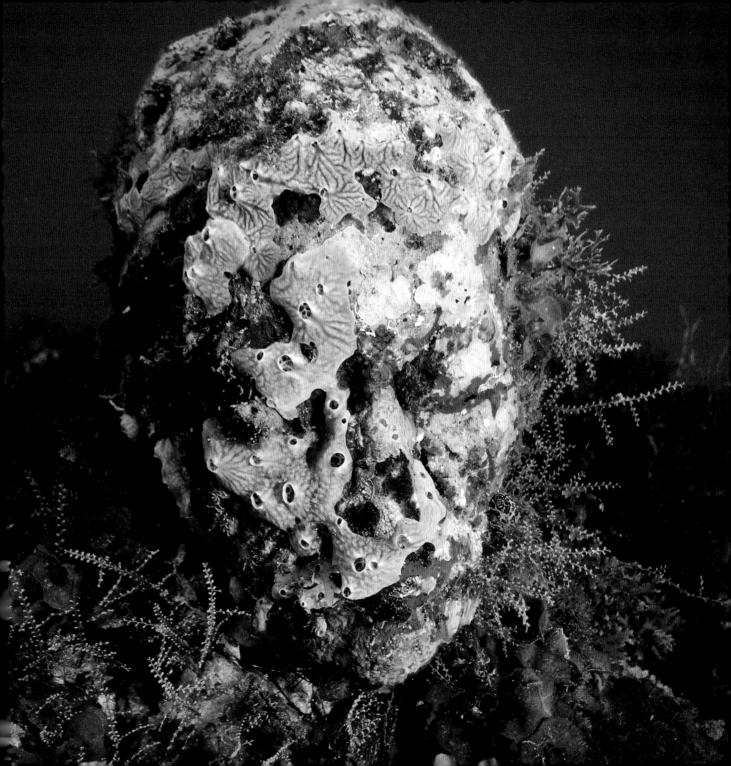

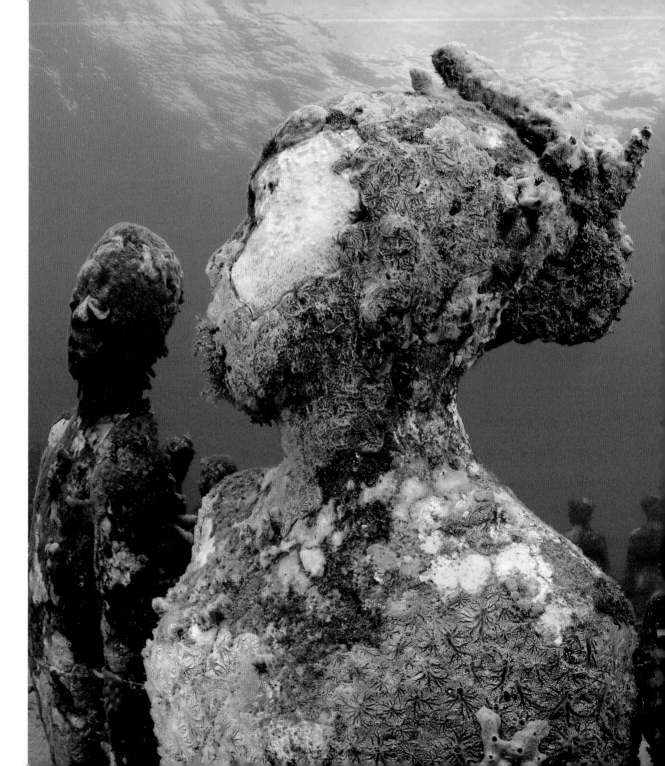

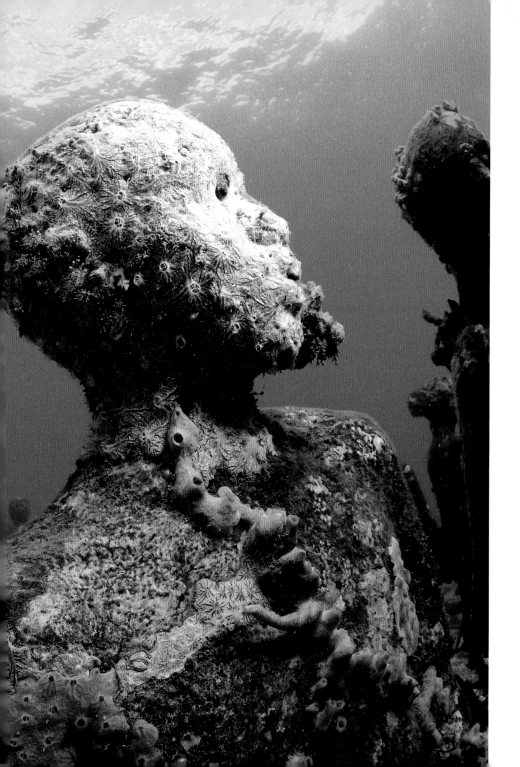

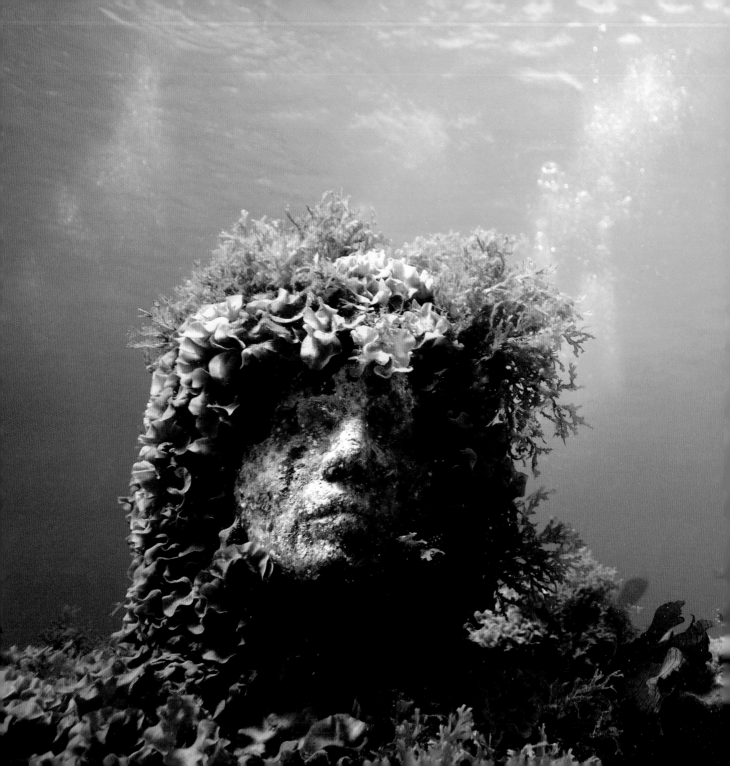

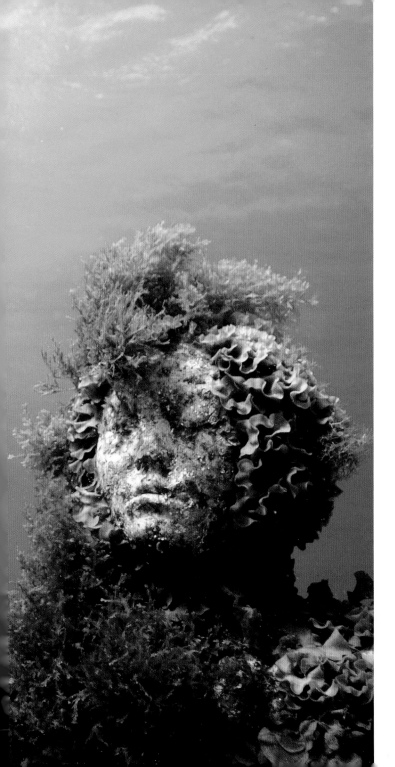

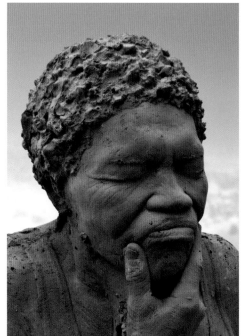

After three years under water, *Charlie Brown,* part of *The Silent Evolution,* is completely smothered in a luxuriant growth of pink sponges, fleshy green algae, and purple patches of coralline algae.

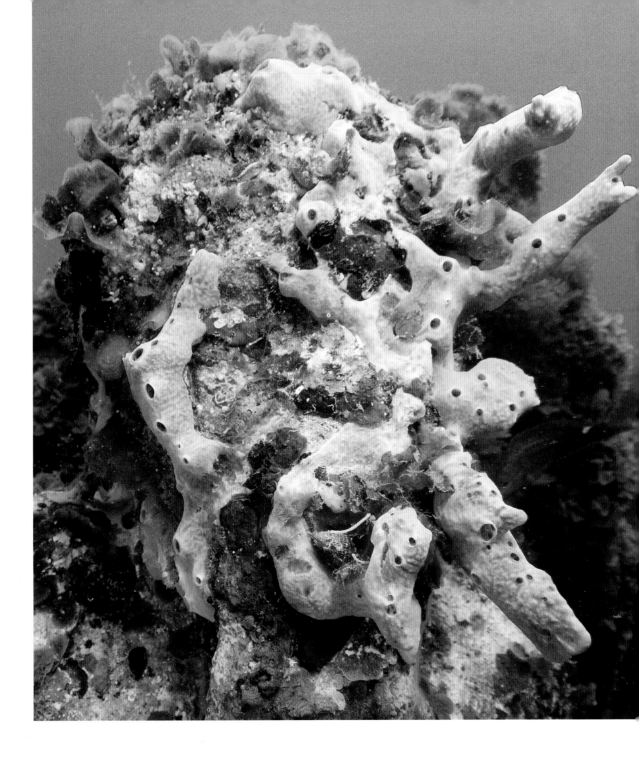

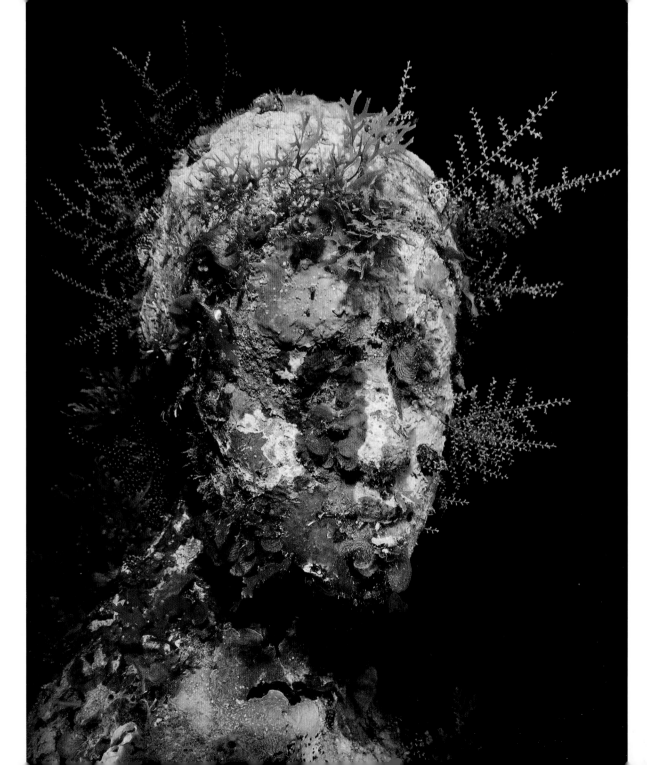

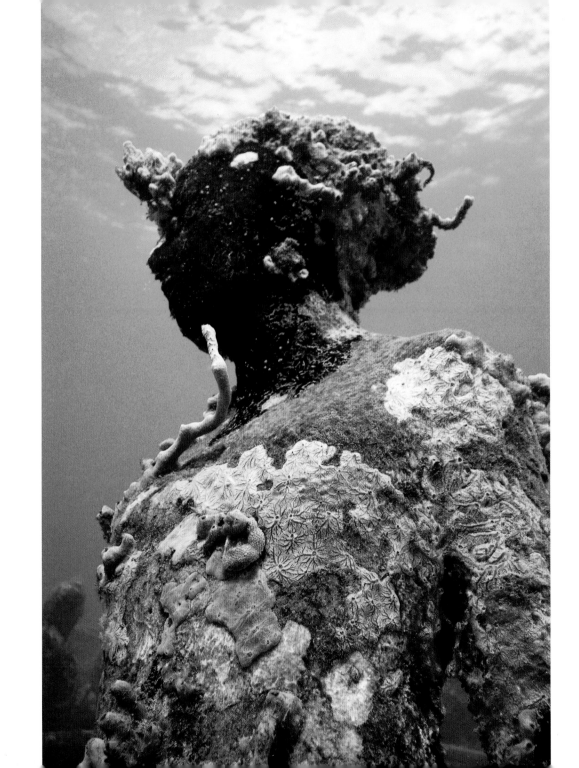

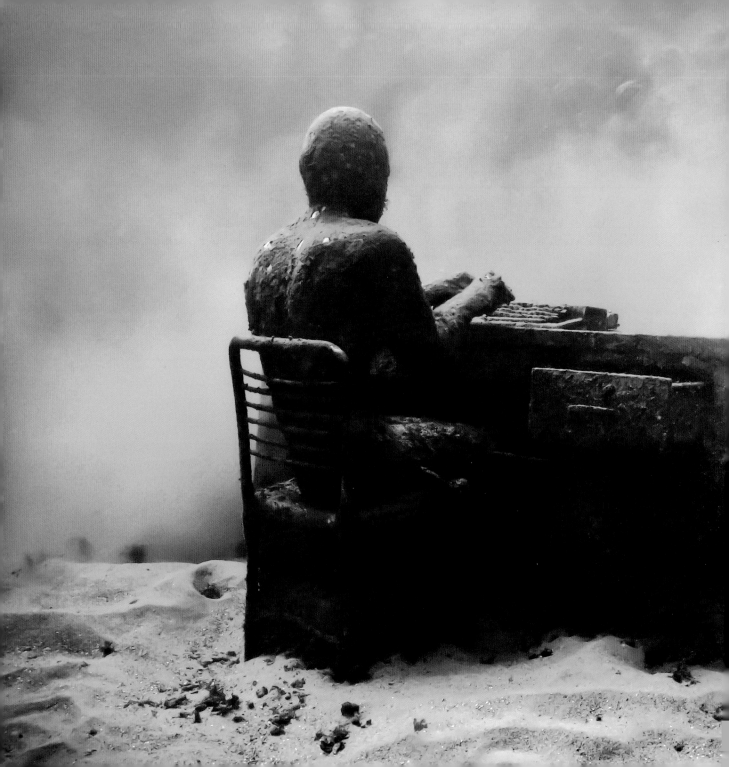

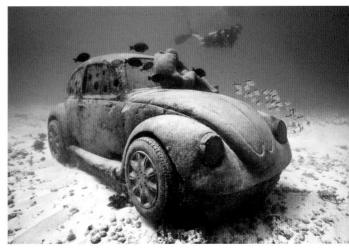

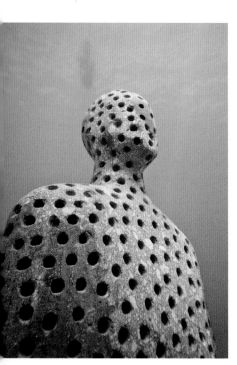
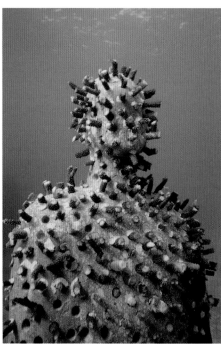
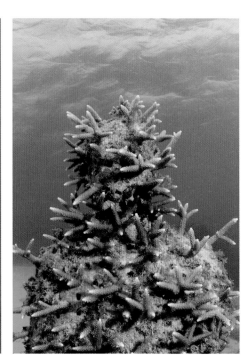

Holy Man, situated four meters below the surface, was propagated with more than 150 fragments of staghorn coral. The species is particularly susceptible to bleaching from increases in temperature and damages easily during periods of storm activity.

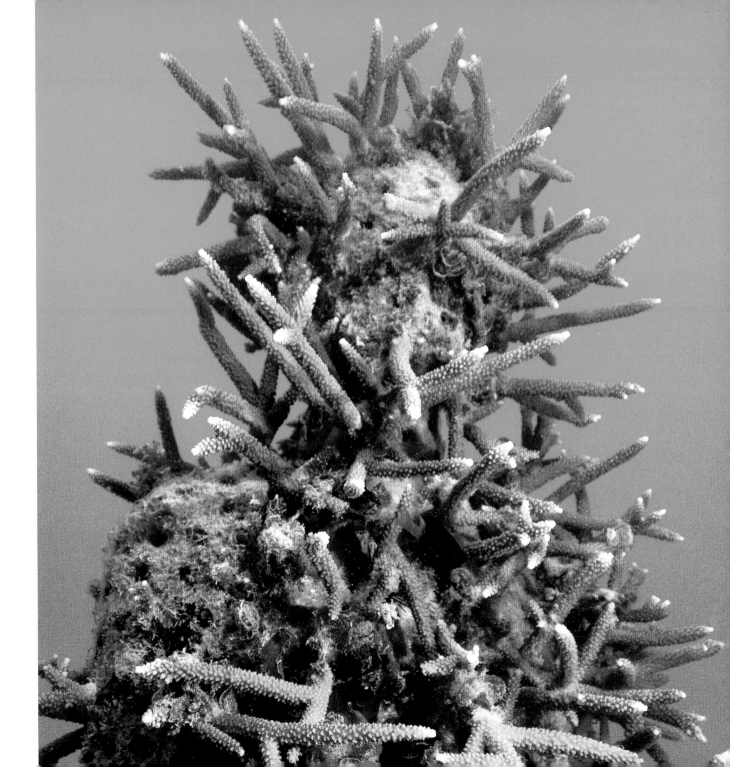

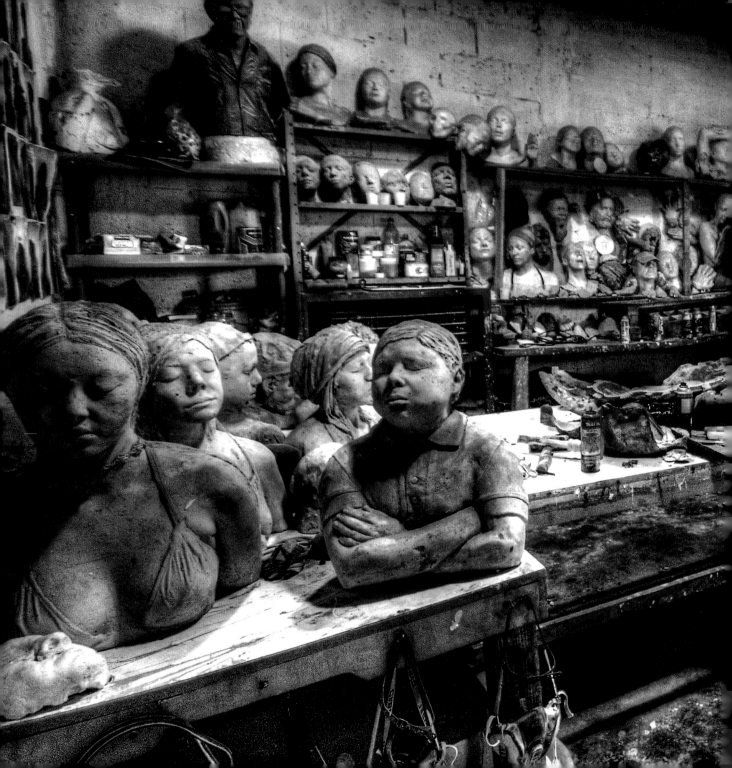

∧ A sculpture entitled *Void*, being prepared with textured surface to encourage marine growth.

> The sculpture of a local carpenter, Leocadio Rodriguez Garcia, called *Lucky*, part of *The Silent Evolution*, waits in the studio.

< (previous spread) A view of the plaster room where all the life casts are made.

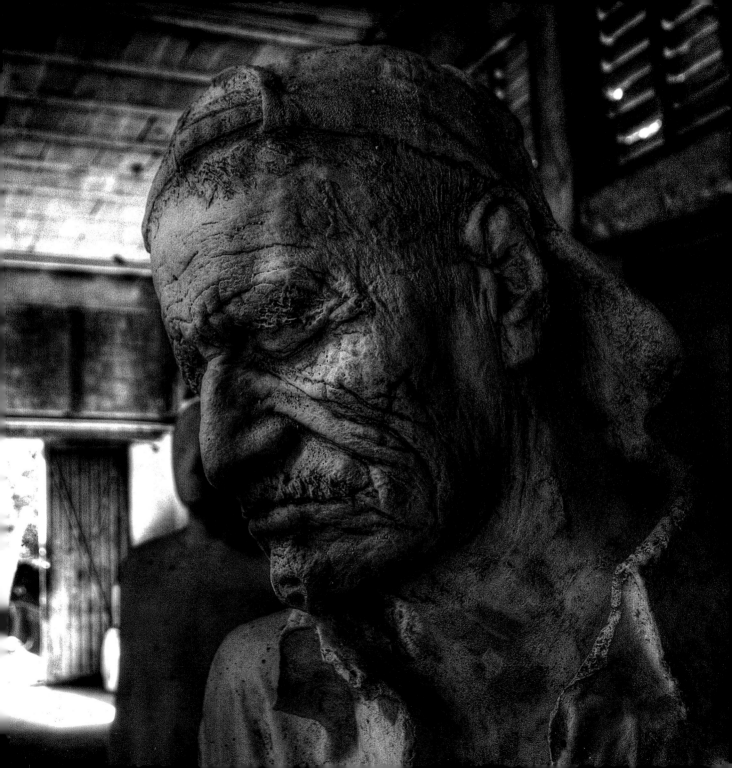

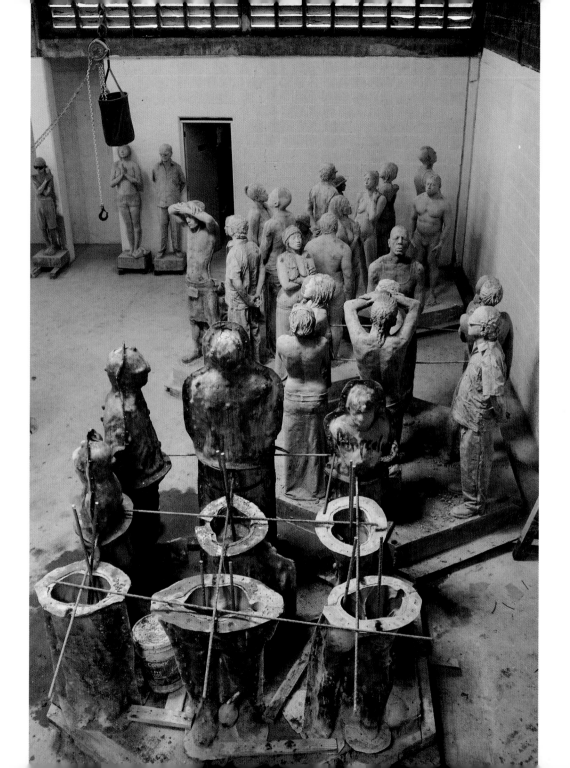

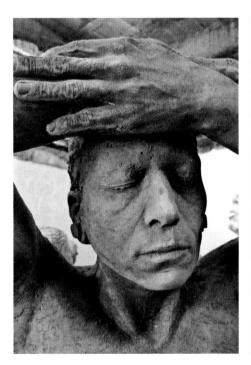
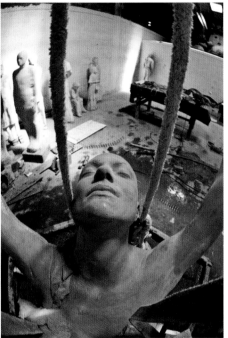

∧ The casting of the model Paz required extra endurance as he was required to stand for over an hour with his hands above his head with heavy plaster bearing down.

> The sculpture *Reclamation* is suspended in the studio while the cement base is fabricated.

< Silicone molds are prepared for the marine cement-pouring stage.

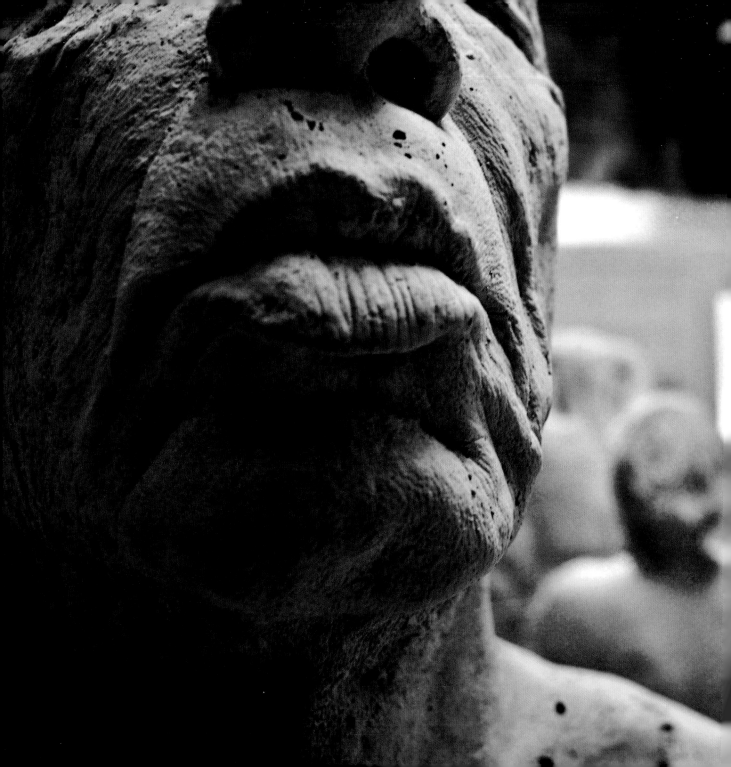

The cement cast of Joaquin, a fisherman from Acapulco, is used for the piece *Man on Fire*. His pitted and textured skin were ideal to promote coral growth.

Final construction of *Vicissitudes* in the studio. The pieces are washed down to remove any chemical residues.

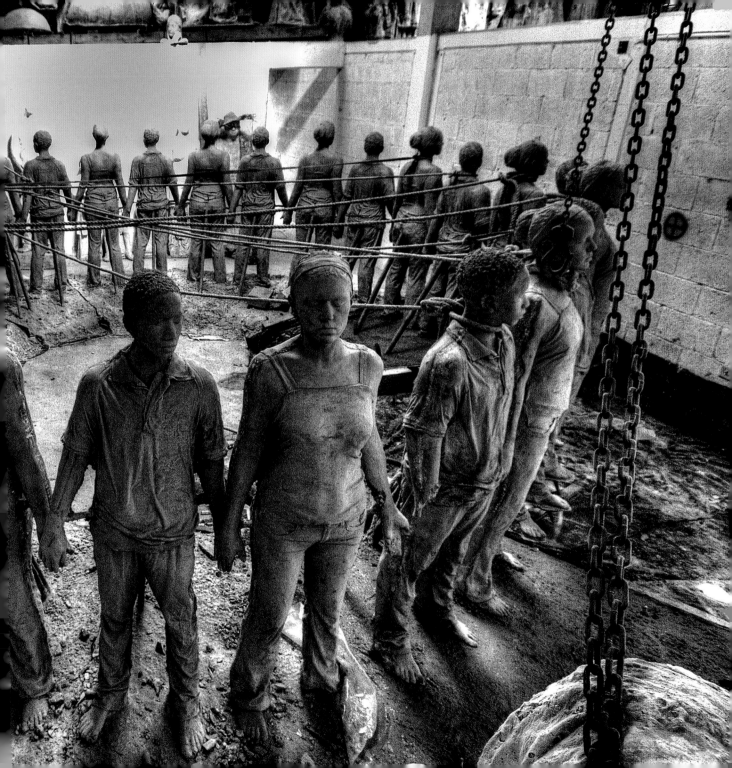

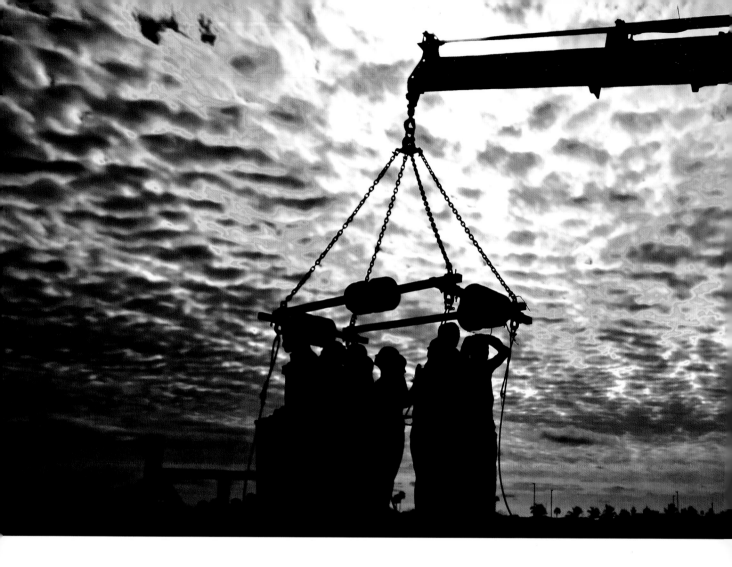

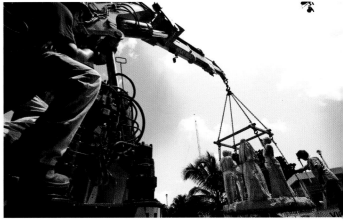

∧ Sculptures are grouped together in modules of ten figures to increase stability and speed of deployment.

> Special lifting rigs need to be made to prevent damage to the sculpture during transit.

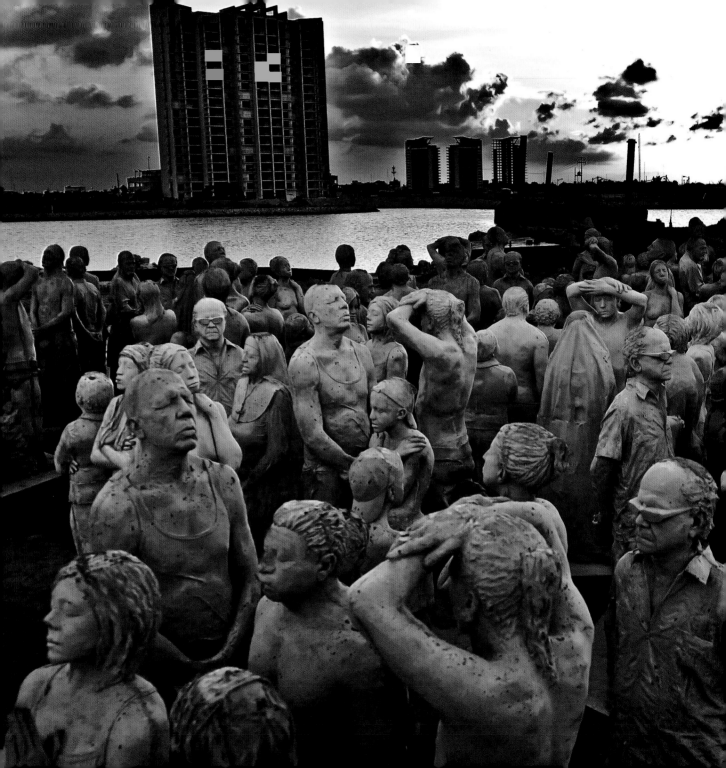

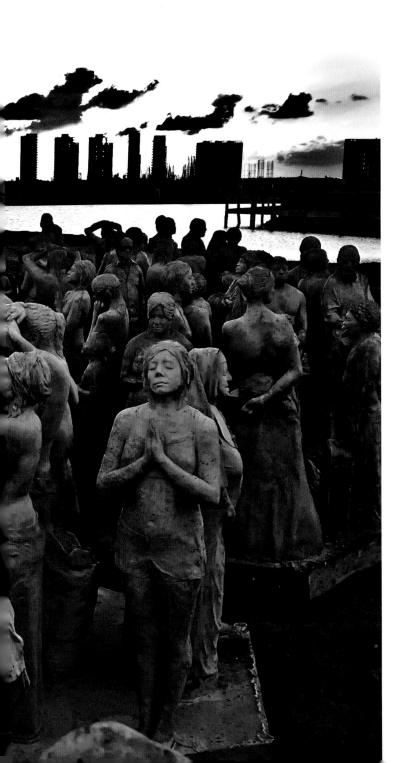

The Silent Evolution installation awaiting deployment from the docks in Puerto Cancún.

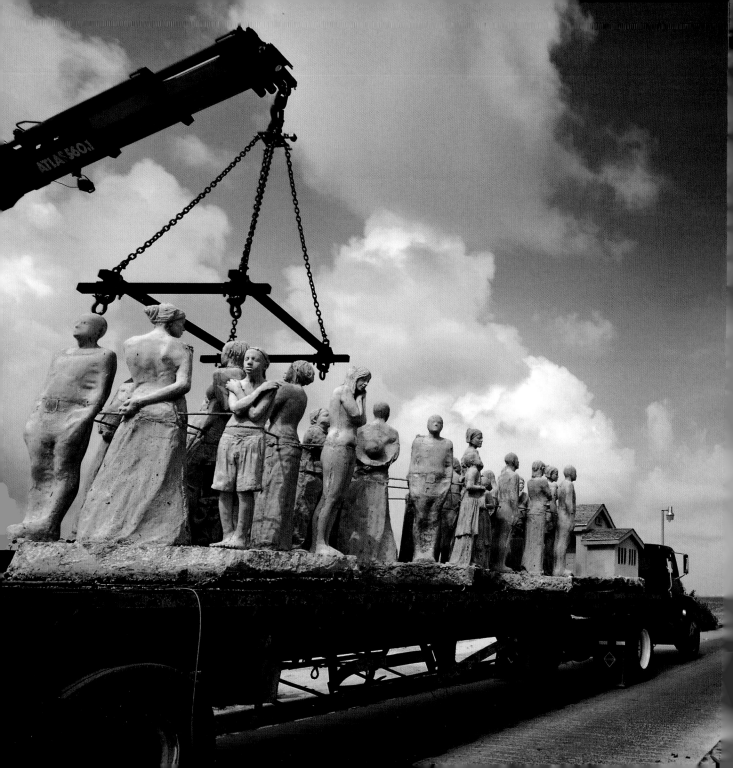

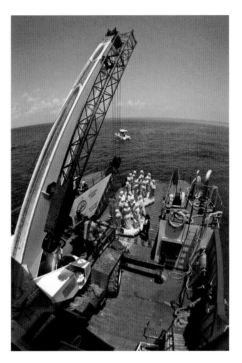

< Thirty figures wait on the truck for the deployment ferry to arrive.

∧ A forty-ton crane operates on a commercial car ferry to install additional modules to *The Silent Evolution*, which can be seen as a dark patch under water in the background.

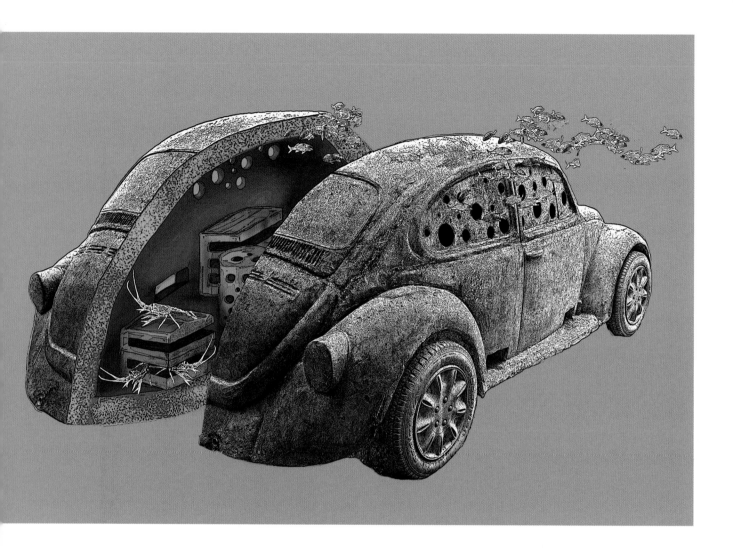

∧ A schematic of the *Anthropocene* sculpture showing the internal living spaces created for crustaceans such as lobsters.

> *Anthropocene* is floated into position using lift bags. The eight-ton life-size replica of a VW beetle required a different method of deployment due to its excessive weight.

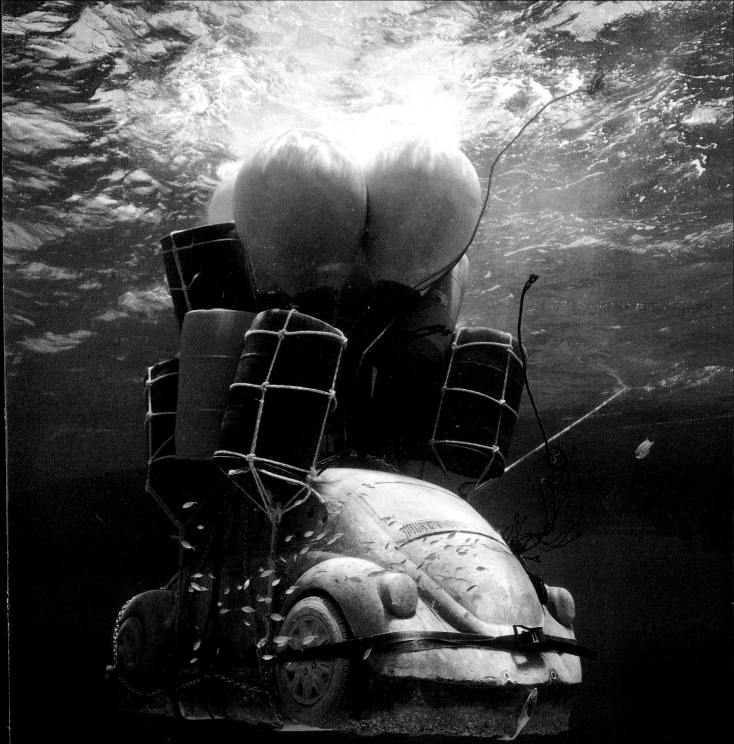

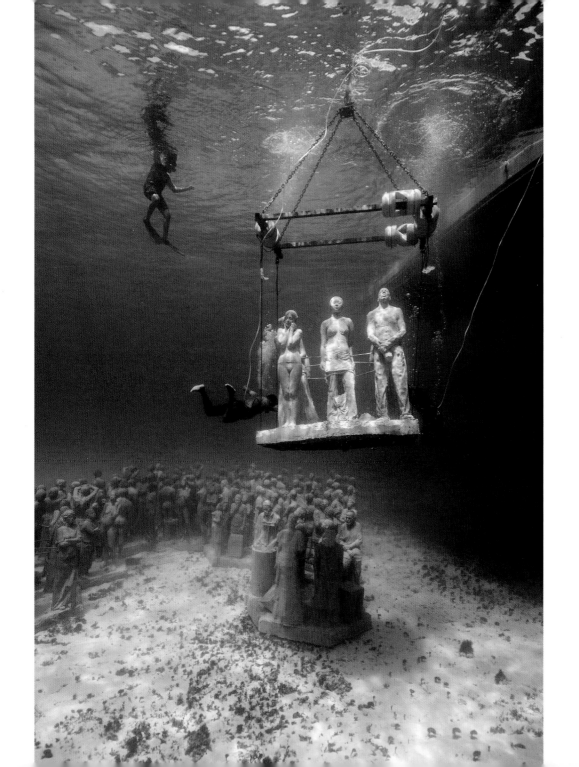

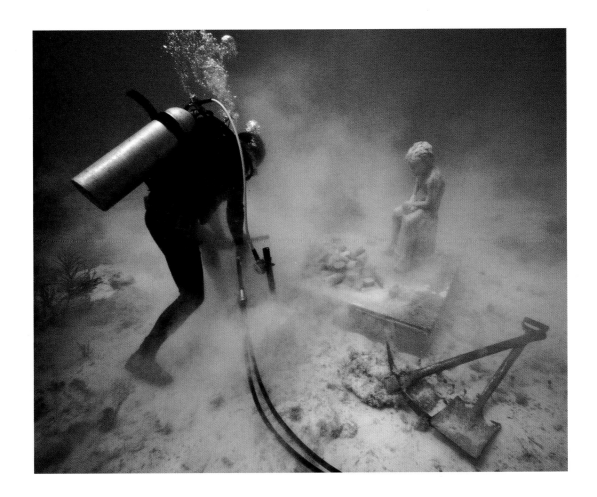

∧ The *Inheritance* sculptures being drilled into place using pilings and a specialized marine hydraulic drill.

< A *Silent Evolution* module is lowered to the ocean floor. Divers using an air supply from the boat ensure exact placement in the planned diamond shape to dissipate prevailing currents.

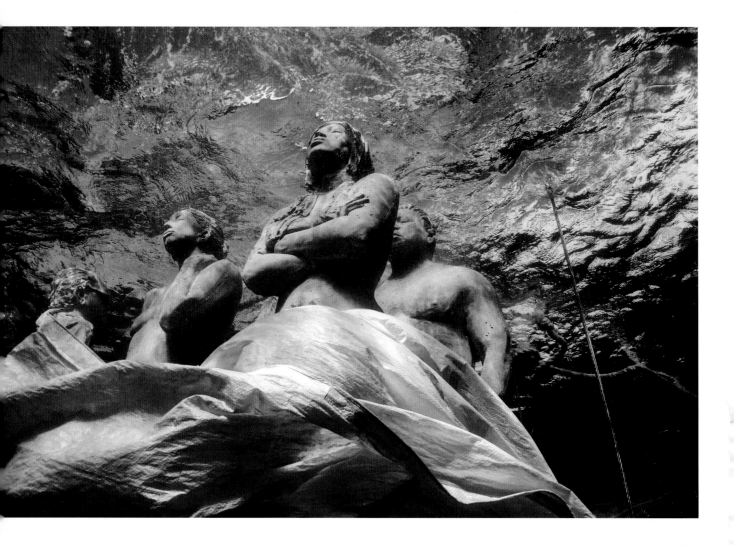

∧ A *Silent Evolution* module submerging below the surface on its way to the ocean floor.

> Once the module hits the seafloor, it is slowly moved into position. Communication between the diver and crane operator through an intermediary snorkeler is vital at this point to ensure safety.

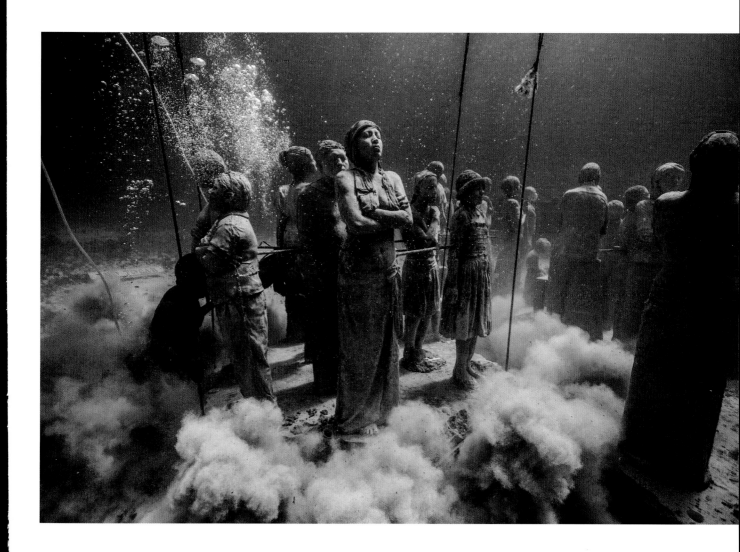

LIST OF ARTWORKS

ABOUT THE AUTHORS

JASON DECAIRES TAYLOR
is an artist, underwater naturalist, and
photographer based in Puerto Morelos,
Mexico. In 2006, Taylor founded and created
the world's first underwater sculpture park
off the coast of Grenada in the West Indies.
Five years later *National Geographic* listed it
as one of the Top 25 Wonders of the World.
Numerous publications and documentaries,
including the *Guardian*, *Vogue*, the BBC, CNN,
and the Discovery Channel have featured
his extraordinary work. He currently works
as artistic director of Museo Subacuático de
Arte in Mexico.

CARLO MCCORMICK
is senior editor of *Paper* magazine. A culture
critic, curator, and the author of numerous
books, he has written for *Aperture*, *Art in
America*, *Artforum*, and many other publica-
tions. He lives in New York City.

DR. HELEN SCALES
is a marine biologist, author, and broad-
caster based in Cambridge, England.
Her research focuses on the ecology of
coral reefs. She has written for *National
Geographic*, the *Guardian*, and *Geographical*
and makes wildlife radio documentaries for
the BBC. You can learn more about her at
helenscales.com.